Unapologetic Beauty

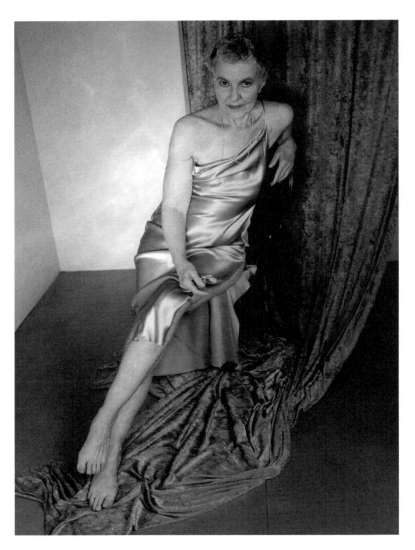

JOANNA AT SEVENTY, 2018

Unapologetic Beauty

JOANNA FRUEH

PHOTOGRAPHY BY FRANCES MURRAY

UNIVERSITY OF MINNESOTA PRESS

MINNEAPOLIS // LONDON

Text copyright 2019 by Joanna Frueh

Except as noted, all photographs in this book were taken by Frances Murray; copyright 2019 Frances Murray.

Published by the University of Minnesota Press
111 Third Avenue South, Suite 290
Minneapolis, MN 55401-2520
http://www.upress.umn.edu

ISBN 978-1-5179-0655-9 (hc)
ISBN 978-1-5179-0656-6 (pb)

A Cataloging-in-Publication record for this book is available from the Library of Congress.

Printed in the United States of America on acid-free paper

The University of Minnesota is an equal-opportunity educator and employer.

25 24 23 22 21 20 19 10 9 8 7 6 5 4 3 2 1

For Kathleen Williamson

—JF

For my parents, Thomas and Jane Murray,
my husband, Harold Jones,
and my twin daughters, Becky Jones and Star Klein

—FM

Contents

AN ART OF *Friendship*

FRANCES IS A PHOTOGRAPHER, AND I AM A WRITER. She is known for her elegant nudes and my writings are known for exploring beauty and the body.

We are great confidantes and playmates, and our friendship is proven, through thick and thin. We count on each other and feel safe together, and from the generosity, trust, exuberance, and delight at the heart of our friendship comes the collaborative strength to discover and develop a new language of beauty that we call unapologetic beauty.

Our desire to comfort and hearten people is a major impetus for our project. *Unapologetic Beauty* is a guidebook that welcomes people into new ways of seeing and talking about female beauty—ahas! of understanding and sighs of relief. It is equally an educational tool and a healing manual. The text and pictures work together to lift readers out of the abyss of imperfections and never-enoughs that the beauty ideal imposes. We present ways to reimagine, so that girls and women can envision, create, and be at ease in their own uniquely unapologetic beauty.

In Frances's and my collaboration, beauty is unapologetically peaceful, happy, playful, brave, relaxed, seductive, pensive, and exhilarated.

FRANCES AND I MET IN 1983 AT A PARTY, when we were thirty-five. When she asked me if I'd pose for her I responded, "Yes!" and our first photo session, in 1985, sealed a friendship and artistic collaboration that have been flowering for half our lifetimes.

Frances began photographing the nude in 1974—images of her twin daughters. I loved the simultaneous boldness and refinement of her photos, in which the body, regardless of age or sex, glows, as if lit from within, and I took to her, because she was kind, thoughtful, down-to-earth, and fun. She makes life easy for those she loves, and I'm fortunate to be one of them.

She reminisces about our first meeting: "I liked how you presented yourself. Besides your hair and body, I liked your style and your voice— your literal voice—and how you projected them. I was intrigued with your elegance and confidence."

THE SEED FOR *UNAPOLOGETIC BEAUTY* was a bilateral mastectomy after a diagnosis of cancer in each breast. The date of that surgery was June 2012, and I was the patient.

"Do you want to collaborate on a book?" Frances asked me in spring of 2014. "Sure!" I exclaimed, before even hearing what her idea was. She recalls my "eagerness" when she "suggested we celebrate your now-transformed body by creating new and inspired photographs." They would set the foundation for a selective photographic history of our collaboration. Writing by me, about beauty and the body and our friendship in art and daily life, would be of equal importance to the pictures.

"What makes a friendship artful?" I asked Frances. "Full realization," she answered, "as if you have created a beautiful work of art." Just as art may open a viewer to aspects of a situation or subject that were previously locked to her, so does an artful friendship.

A beautiful friendship is "like art, below the surface," Frances has declared. Depth comes from "growth, its potential and actuality," and from an exploratory impetus and excitement.

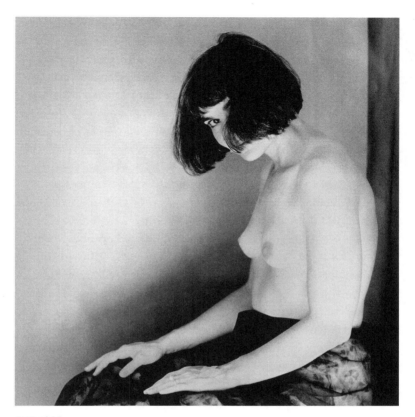

EYE, 1985

In an artful friendship, people feel "no difference, no distance, after not seeing each other for years," Frances shared in a recent conversation. Tucson has been her home since 1974. It was mine from 1983 to 1985, and I returned to live there in 2006. She and I reconnected seamlessly in friendship and the studio when I visited, and throughout our years as friends we have each gravitated toward the other professionally. Frances invited me to read poems of hers for a slide and audio piece, *Psychologue,* which she presented at the University of St. Louis, Missouri, in 1987. Her photos appear in magazines, books, and galleries, and I wrote an article about her work for the *Tucson Weekly* in 1988, an essay for her retrospective exhibition catalog in 2007, and a piece for a self-published book of hers in 2014.[1] I asked Frances to collaborate on photos for two of my books, *The Glamour of Being Real* (2011) and *A Short Story about a Big Healing* (2013).[2] My first publications, in 1973, were art criticism. I'm an author, a performance artist, scholar—an art historian and cultural historian—and an emerita professor of art history. Photos of me appear in my books and are often nudes, full of confidence and sensuality. The two of us have received awards in our respective fields, including Frances's National Endowment for the Arts (NEA) US/Japan Exchange Fellowship in 1987 and my Lifetime Achievement Award from the Women's Caucus for Art in 2008.

OVER THE YEARS WE WROTE LETTERS TO ONE ANOTHER. I discovered a couple of hers, from the 1980s, when I was clearing files in preparation for a move (within Tucson) in 2015. As Frances confided in a letter from that time, "I was burned out and needed solitude," so she drove into the Catalina Mountains, directly north of Tucson. In the car she listened to Pachelbel's "Canon in D" and "burst out crying—I think a reaction to the past several months of pushing, working, and anxiety [readying for an exhibition]. I was reminded of the day we walked there and our long talk. Most times life is intense—I wouldn't want it any other

way—I'll bet you wouldn't either. Just an occasional break." Her tone shifts: "Did I tell you I received a letter from the NEA asking me to be a candidate for their US/Japan Fellowship? Almost blew my socks off. Forty artists from the US were recommended. They will pick five people." To be one of the five was an honor, and as I wrote above, the NEA chose her. In a letter from 1986 she speaks about my bodybuilding, our mutual interest in the erotic, a famous performance artist soon to appear in Tucson, and her current recovery from a hysterectomy. She suggests in one of the letters that we "indulge ourselves" in a phone call.

Frances's and my "continuing interest in the other [means that we are] processing life together, sharing [by] putting yourself in the other's shoes [and experiencing together life's] disappointments along with high points." Since 2006, Frances and I have marveled at our friendship as we reveal ever more of ourselves in its simultaneously breezy and sturdy embrace, from the ins and outs of trials and triumphs in her family of spouse, siblings, daughters, grandchildren, and in-laws, to the passions, losses, and fulfillments in my romantic relationships, and within the soul-and-mind-inseparable-from-body changes in our private and professional lives and those of our friends, young and old, as we all age.

Artful friends help one another realize that, as Frances says, "mistakes turn out not to be [and that] adversity turns into opportunity [because friends help each other] let go of anger and resentment." So in this world that amazes, enlivens, and saddens us, Frances and I breathe easy in our friendship, grateful that an artful friendship is, in her words, "a renewal of the spirit."

We share an aesthetic of elegance and edginess that characterizes our individual work. Prime aspects of that aesthetic are sensuousness, psychic and emotional honesty, and erotic inquiry and suspense. "In our individual work, we delve into the underbelly of the psyche," Frances has said in conversation, "and not everyone likes doing that. We have an individual and mutual comfort level with that and easily discuss a

range of intimate subjects. Those conversations are invaluable, and they enrich us."

The photos exceed conventions of beauty while also relishing some of them. Glamorous heat held close to cool astuteness characterizes Frances's work. Her lighting, like that in the most renowned glamour photos such as those by Horst B. Horst in the mid- to late-twentieth century, sings with dramatic brights and shadows that emphasize clarity of form while simultaneously shaping it in mystery. As in Horst's celebrity and fashion photos, radiance and darkness, as well as concentrated focus on the subject, enhance it, so that a glamour photo both literally and figuratively illuminates the subject's "perfect beauty." When the subject is a woman, that beauty is her physical and spiritual wholeness, so she is recognizable as herself, and more—a beacon of purity and enigma, a strong presence in an erotic space.

The glamorous quality of the light in *Unapologetic Beauty* may have a viewer thinking that Frances's lighting is artificial and highly controlled. Not so. She works only with natural light, letting *it* be the master. She chooses locations according to the appeal of their natural light over a particular amount of time, such as 2–4 p.m. during summer in the living room and dining area of my house, when a soft glow suffuses them. (Frances's studio, which is at her home, has been the setting for most of our sessions, except for some at my house between 2011 and 2017.) She *directs* light, using crystal prisms, mirrors, and reflective surfaces, such as a 20x24-inch board covered with tin foil. That method numinously reveals a model's body, making the use of Photoshop minimal.

Frances and I go against the grain of glamour photos' constructed perfection, because we offer "imperfection." And that is unapologetic. While glamour photos may surprise the viewer with truncated figures or a disorienting space, the photographer seeks to entrance, whereas Frances's pictures may awaken someone to an unsettling psychic reality. Particularities of my body practices and appearance follow some beauty

standards while upending others. I enjoyed shapely muscles long before First Lady Michelle Obama's arms were in vogue. I began bodybuilding around 1980, taking a break from 2008 to 2014, when yoga, to which I've been devoted since my early twenties, and Continuum, an organic, spontaneous kind of movement, occupied me intensively. For most of my life, I've worn my full, shiny hair long. The *beauty marks*—not battle scars—as I term the lines where my breasts used to be, grace my chest and are in full view in our photos.

The above complex of elements produces a soul-and-mind-inseparable-from-body eroticism that challenges both high art and popular images of aging, sexy, glamorous, or surgically marked women. Frances describes my sexuality as "intelligent, direct, and multidimensional." She absorbs that aura and then reflects it in the photographs.

Women and aging has been a deliberately significant subject in my writing since the 1990s, and, of course, I have been growing older in published photos of me all along, from the first set in my *Erotic Faculties* (1996) through those in *A Short Story about a Big Healing* (2013). When I was a little girl I loved looking at playing cards displaying pinups whether scantily dressed or unclothed. I felt sexy and beautiful. Maybe that contributes to my happy composure as a nude in the eyes of photographers. The photos in my books belong within my work as a performance artist whose memoirs and essays serve as texts for performances. The pictures themselves are a kind of performance. It features genuine gestures and facial expressions, the self-awareness and relaxation of a particular person. Frances perceives my "great ease with [my] body," a psychic as well as corporeal "honesty and forthrightness. You're so comfortable." That differs, she notes, from discomfort about her own body, although she knows that in her portrait work she "can bring out bodily ease in other people."

THE STUDIO OF DESIRES—that's what we call our collaboration.

The play of our desires ranges from vulnerability to elation when experimenting with props and costumes, to following each other's verbal and physical leads, to deciding which photos are keepers, to chatting about items that we'll feature from Frances's thrifting and my wardrobe and petite jewelry trove. We effortlessly select props, clothing, and the photos themselves. Frances's and my empathic artistry, produced from our interactions and conversations in and out of the studio, contrasts with the prototype of a model silently posing for a photographer. While she calls me her muse and model, both of us authoritatively observe and direct.

"Choosing props when Joanna and I collaborate is always an adventure, a whirling of ideas and images," enthuses Frances, and she continues: "I've shopped for years in thrift stores for special items that sing to me! They can be vintage fabrics, clothing, or compelling objects. I may not have a specific use in mind at the time of purchase, but I'm sure that it will follow."

Each item, whether from a thrift source or another, must be just right, not only in form, texture, and hue—a scarlet-colored velvet cloth that drapes across my lap as a skirt; a pale peach chiffon shawl; a dark purple pansy (that we picked from a hefty pot outside a restaurant)—but also because it is classically beautiful. No screaming, "Look at me!" Nothing whose personality or symbolic presence outweighs the overall temper of a picture.

Our studio sessions last for around two hours, with the first twenty minutes or so given to snapshots that acclimate us to the moods and intentions of here-and-now interaction. We take many more photos than will ever become public. This is especially true since Frances started using a digital camera in 2012.

We work in sequences, each with me in different clothing. I'm good at holding a pose and returning to one, though the Studio of Desires is highly improvisational, and most often I'm "dancing" through a sequence,

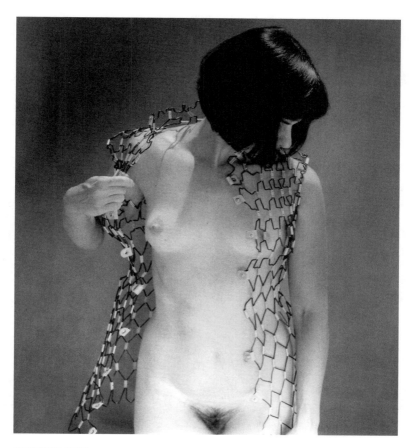

CORSET I, 1985

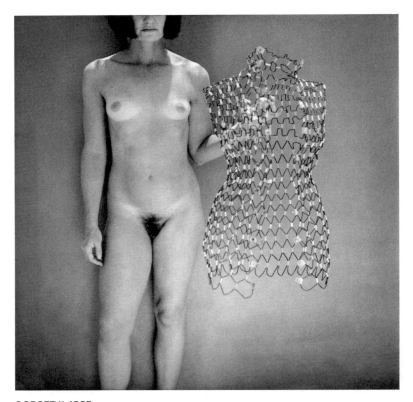

CORSET II, 1985

moving easily from one posture and idea to another, at Frances's sugges-
tions and my inclination.

Since Frances began using a digital camera, we look at our efforts
throughout the session—always after finishing a sequence and some-
times during it. Frances eyes every picture immediately after taking it,
and when I hear, "Wow!" I know that I'll say the same. We delete as we go
and then look again right after our session, if we have the time and energy,
or soon afterward in order to decide what to save on her computer. Our
immediate agreement astounds even us.

In the Studio of Desires our intuitions and spontaneity are ebulliently
in sync. As Frances says, "We work in tandem listening to each other's
ideas and concerns—it's rich and serious and always fun, extremely
trusting and respectful." Our creative rhythms, unloosed together over
decades, have matured cooperatively, so that, as Frances affirms, we
"allow ourselves to continue pushing the creative envelope" that we
share. Individually, we have become perfectionists in our crafts, and that
could cause conflict in collaboration, but corroboration is the result with
Frances and me, who kibitz as we work, never fighting or getting testy.

The Studio of Desires and daily life permeate one another, and Fran-
ces and I relish that porousness. We *see* one another there, in the mutual
permeability of emotions and ideas. *Being seen* is itself a desire, a current
phrase that denotes the goodness of being understood by another
person. She looks at me through her camera, but we both see each other.
Our mutual responsiveness tells that truth as does the growing emotional
range in the photos. Insight and solicitude are reciprocal desires.

FRANCES WAS ONE OF MY PRIMARY HEALERS during the 2012
breast cancer experience, as important as the surgeon and oncologist,
as the nurses and pharmacist in the chemotherapy infusion center. She
was an angelic companion from diagnosis through the end of treatment,
checking often on my well-being, driving us on girl dates for lunch or to

stroll around a snazzy shopping mall, talking with me about anything that I needed to consider out loud, and e-mailing me in June 2012 when she was going on a vacation: "I'm on holiday, but not to you."

She helped me try on clothes in the dressing rooms of thrift stores and boutiques soon after surgery, when I was still sporting a drain in the right side, which had bruised to black from armpit to hip and needed more time to heal than the left. Frances was with me during the port procedure the day before chemotherapy began, and she accompanied me to the first and last infusions and others in between.

The healing process for me entailed an unexpected creative tsunami. In April 2013, I self-published a succinct book titled *A Short Story about A Big Healing,* in which the breast cancer experience that I underwent figures prominently: diagnosis the first week of June 2012, a bilateral mastectomy without reconstruction the end of the month, and chemotherapy that began in August and ended in October. The overarching theme of the book is a healing of the heart: passage into a greater ability to give and receive love.

I asked Frances to collaborate on pictures of me for the book. She remembers: "As I photographed you, your raw honesty touched me. You were as beautiful as ever and reflected a serene acceptance of yourself and your smart body. Smart—your psyche knew what your body needed. It was that calm acceptance, that ability to communicate self-assurance and beauty that led me to ask you to collaborate on a book not just dealing with breast cancer but talking about the idea of beauty."

The *Big Healing* session with Frances was an adventure. When I entered her studio, one day in March 2013, around nine months after the mastectomy, I said, "I'm feeling fragile." She responded in her light, gentle way, "I knew you would." I felt beautiful walking into her space and throughout the session, and we played like we always do as part of the keen focus on our job, which, we agree, is to create beauty. The time sped by; we shot 436 photos.

We were tired when we met, which was a first, but our session lasted the same amount of time as usual. Working with each other energizes us, and only between sequences did my weariness surface. Well after an hour we discovered that we hadn't used a necklace I'd brought. "More?" I thought, with a silent "Oh, dear" of fatigue, and then our interaction revitalized me.

Our *Big Healing* session was as creative and lighthearted as always, and Frances's sensitivity to me was utterly compassionate. In her studio that day I felt untypically tender emotionally, and I also felt as comfortable in front of an artist's camera as usual.

SELF-EVIDENCE IS THE ENCOMPASSING TITLE of the 2013 postmastectomy photos. The *Big Healing* session begins that series. *Self-Evidence* suggests unvarnished truth. Yes, but the facts are ever-changing as soul-and-mind-inseparable-from-body transforms. Impermanence is always true, every instant. So self-evidence can never be a fixed state, a static fact. Rather, self-evidence is proof not only of a *changed* person, but more precisely and comprehensively, of a *changing* person. *Self-Evidence* testifies to the shapeshifting that is a fact of fleshly living.

So the *Self-Evidence* photos are not representations of a finished product—a woman after a bilateral mastectomy—or documentations of an obvious physical change—a chest without breasts—but, rather, revelations, traces, and validations of a personal history. All personal histories come into being and transform through interactions. They are a basis of everyone's self-evidence. The very particular evidence of radical change in our postmastectomy photos results from our devotion to beauty and to one another.

WHACK, SMACK, AND SHOCK UPON SHOCK. On Christmas Eve 2016, I was given a diagnosis of metastatic breast cancer. Among the

surprises and pains, physical and emotional, wrought by a very potent chemotherapy, I could catalog those that affected my appearance. But after the fact, two of the new looks caused by the treatment (affecting my eyebrows and nails) stand out as the most disturbing. Baldness was not one of the duo, possibly because I expected it. But like baldness, the others arrived not by choice, though I *chose* to have my stylist shave my head before the hair fell out. Lack of control contributed mightily to my disturbance. Because I could not contain unwanted changes in my appearance, managing my body with my usual cleanliness, grooming, and cosmetic and clothing enhancements became sadly unsatisfying and seemingly pointless.

My eyebrows are thick and dark and nicely shaped, and the hair became measly. My nails turned yellowish, whitish, and bruised-looking, and many of the fingernails started to peel off of the nail bed. The medical oncologist said that chemotherapy was causing the corroding nails and that they'd return to health. I didn't fill in my brows or have them tattooed, because both required too much work and I like low upkeep and typically wear little makeup—light foundation, a lip color that doubles for cheeks, and sometimes eye shadow. That's comfortable for me. Indeed, comfort was of the essence, and it was hard to come by, so I took it where I could get it, in wardrobe standbys such as the frequently worn soft cotton scarves decorated in Indian block prints that I wore on my head to cover what I called my Buddhist priest look, and the earrings and necklaces, both bold and delicate, ones inherited from Mom and her mother and others that were gifts from my sister. They bear good juju and touch me like loving hands.

The cultural equation between health and beauty unconsciously prejudiced me against myself. On a primordial level, health/beauty translates as unblemished/impeccable/strong, and its opposite as soiled/disgusting/weak. When one is repulsive at culture's gut level, she readily questions her beauty, and others experience her as dangerous to their well-being, from how they feel to how they look.

Cancer can be a very visible illness. Not all illnesses are. In the cancer center where I've been treated since the Christmas Eve diagnosis, and in the chemotherapy infusion room where I volunteered from 2014 into 2016 to attend to patients' needs, including the keenly important one of talking, I have seen people with no eye, with part of the face gone, with a huge tumor in the neck—and with the pallid skin and scarf-covered head that marked me or that I imagined was doing so. The visibility of a marred, sick, and/or feeble body is negatively charismatic, an "uglification" that can forcefully engender squeamishness and fascination. Such uglification exists unconsciously in an observer as a contaminant, possibly contagious, as well as an invitation for sympathy.

Prejudice against one's own appearance constitutes apology, so my confidently unapologetic beauty had gradually diminished along with the spirit in my eyes and aura, the color in my cheeks, and clear vision of myself. Who was that standing in front of the mirror? With a pathetic smattering of hairs for eyebrows? With those nails that she feared were fungal and that she watched sicken day by day?

I was beside myself.

A somatic stranger suffering from bewilderment in soul-and-mind-inseparable-from-body.

Mostly rational yet congested with delusions and frighteningly down.

I initiated conversations with Frances about death, and she did her full-hearted best to alleviate my anguish with listening and immense patience, with jaunts to thrift stores and restaurants that ordinarily give us the commonplace pleasures that to me are the most fun and the most meaningful. I, however, feeling only faintly jaunty once in a blue moon, was pretty inconsolable.

Extreme depression, filled with anxiety, indecisiveness, darkness and inertia, which was so unlike me, and caused mostly by chemotherapy according to a psychiatrist I consulted, colored everything. A veil seemed to internally shroud my forehead. Reality had been obscured and distanced,

JANE MURRAY, FRANCES'S MOTHER, CIRCA 1995. PHOTOGRAPH BY MARGARET MURRAY.

and I felt far away, from myself and the external world. Imagine, for instance, obsessing about the breakdown of appliances and structures in your home. That was me—and surely it was metaphoric, springing from terror about my body.

I didn't recognize my appearance because I felt unrecognizable deep within. Even so, shamed by cultural aversions that I had internalized, unapologetic beauty came to the rescue! Its base of true character cut through the Gordian knots tied from physical and mental suffering. In the chapter here titled "Beauty Redefined," I develop the idea of true character as "the seat of radiance," which "lies not in appearance per se but in the distinctive qualities and essential traits that physical appearance makes visible. True character lies deeper than personality, which is the mere surface of someone's being." True character is the key releasing oneself from fake passions and desires pushed by hyperbeauty, which is today's beauty ideal and the subject of the chapter with the same name.

I am normal. Now, my brows are full, like the hair on my head, which grows luxuriously. My nails are pink, like my complexion, whose paleness had been reddened with intermittent blotches. Prognosis? The same as yours: death at an unknown hour. Now, I sparkle.

FRANCES FEELS CLOSE to women's breast cancer experiences. Her mother died of the disease in 1997 when Frances was fifty years old. "I was sixteen when my mom had her radical mastectomy in 1963," Frances recalls. "My mom was forty-four years old and had just returned to Ireland, from the States, to raise her six children, all under nineteen years of age, as a widow. The cancer was a traumatic event in all of our lives, but mostly for her. As I reflect back on it now, I realize how strong and brave a woman she was. Her second occurrence was in 1995 and she had radiation then."

Powerful visions of her mother linger with Frances. "My mom initially was fitted for two prostheses," she recounts, "and as she traveled home

on the bus with them in a beautifully wrapped box, she said that she felt like she was carrying the crown jewels! Ultimately, she did not like wearing them and resorted to stuffing her bra with toilet paper, and bits of it would drop out, leaving a trail of tissue."

Trails of tissues, for the tears of cancer patients and their families. Trails of tissues, living matter taken from the chests of a multitude of women diagnosed with breast cancer.

FRANCES AND I ARE UNIQUE within the history of art, though Frances's figural photos belong in the tradition of the nude.

In Western art the nude, technically, is a human body clothed in beauty. From its ancient Greek beginnings with sculptures of Aphrodite, the goddess of beauty and love, to her descendants in the Renaissance up to the present, including the body and performance art of women that has educated as well as shocked the art world since the 1960s, the female nude is a staple of artistic representation. (So is her male counterpart.)

In our collaboration, I am the nude, clothed in the numerous beauties of our Studio of Desires. There, I am a contemporary Aphrodite, and I laugh a little to think that breasts are, of course, common and prominent in Western art, but no longer in Frances's and mine.

"I have always been into erotica," remarks Frances, "and it must tie into my Catholic background. The body was viewed in secrecy, the beauty of the human body. You don't undress in front of people and don't talk about your body with girlfriends. The body is a taboo subject. When something is cloaked in mystery, it becomes more compelling."

Among artist/muse relationships, three comparisons come to mind, though they are fundamentally different from Frances's and mine: Tamara de Lempicka and the woman who modeled for four paintings dated 1927, including three nudes; Dante Gabriel Rossetti and his muse Jane Morris, the subject of many works between 1857, when the first one is dated, and

1881, the year before the painter's death; and Claude Cahun, born Lucy Schwob in 1894, and Marcel Moore, born Suzanne Malherbe in 1892, who met when Cahun was fifteen, became lifelong partners, and collaborated on photographic portraits mostly of Cahun. In the history of Western art, affairs are common artist/muse phenomena, and an artist and muse/model relationship between women is all but nonexistent—as far as we know.

Unlike Frances and me, de Lempicka and her muse were neither collaborators nor intimate friends. The model is anonymous, and their intimacy was sexual, a liaison that lasted a year. While the subject's body fills each canvas, spatially and with its torrid allure, her character is shallow. That is due in large part to the artist's Mannerist, Neo-Cubist exaggerations, which maximize the model's sultry availability, to the detriment of other qualities.

Rossetti and Morris were fraught, on-and-off lovers, and they also bonded as nonromantic friends. Like Frances and me, the length of their artistic relationship is unusual, but unlike the images of me, whose face and body convey a range of expressiveness, the numerous portraits that Rossetti produced of Morris confine her to the iconicity of a Rossetti Woman, whose beauty includes stylized features such as voluptuous lips, large, soulful eyes, and big hair, and whose mood is dreamy unto melancholic.

Cahun and Malherbe's photographs of Cahun show masquerades of femininity and masculinity that neuter any one identity or gender. The couple renamed themselves, and the "real" Cahun disappears into the image of a Buddhist monk, a male dandy, a coyly feminized strongman. She sits naked in a pose resembling the yoga pose Virasana, covering her breasts with her elbows and her eyes with a mask: those elements along with close-cropped hair declare androgyny, and we often see her shaved head, which also appears to declare her androgynous. The "real" Cahun? Ambiguous, unnameable. In contrast, Frances and I show a Joanna whose gender is feminine, even after a bilateral mastectomy, and whose identity we have not sought either to obscure or multiply.

In artist/muse associations, the artist is usually the more educated member of the pair, whether in art or in general, and the leader of the artistic endeavor. Frances is a self-educated artist who has taken college courses, I have a Ph.D., and we are equals. Two women who collaborate over decades and are professional peers and dear friends, without being romantically involved, is unusually exemplary of intellectual and artistic desire conveyed through the fires of inquisitive aspiration.

HOW DIFFERENT are Frances's and my as-is mastectomy photos from those that most regularly appeared in Internet searches I did in 2014–15 and in early 2018. The earlier batch straitjackets the body, focusing on it from chin or neck to waist. Such fragments of the female figure deliver a depersonalized, clinical feeling, even when produced by women who themselves underwent surgery. The pictures might seem appropriate for a doctor to show a patient. The view estranges an observer with its objectivity, a look at the external facts of surgery, a document of them, even though she may strongly react, with sympathy, revulsion, or curiosity because of her own knowledge or fear of breast cancer or her own mastectomy passage.

The 2018 search brought some of those "clinical" views, but others had gained popularity: surgical marks decorated with tattooed scrolls, flowers, mythic animals, and abstract designs; smiling faces; and portraits showing the subject wearing jeans below her naked torso. Self-worth and joy are pronounced. The new iconographies convey welcome feelings and ideas: I'm a human being and here's what I can do with myself! Love my body, its size, shapes, and color, adorn and cherish it! I've got choices! I'm not the misery that a breast cancer diagnosis and surgery can generate. Yet whether the pictures register a traumatic event and detach viewers from the human being who underwent it or display subjects who show themselves as self-respecting individuals with whom viewers might comfortably identify rather than dread or pity, uniformity prevails in

the deficient range of dress, body postures and gestures, and overall expressiveness.

Frances and I offer an alternative to the repetitive, standardized models. Our work's sensory emphasis engages the viewer through haptic and kinesthetic qualities. Haptic—relating to touch. Kinesthesia—awareness of a body's movements, weight, position, muscle tensions. A description of *Self-Evidence* by a viewer who articulates its sensory distinctiveness, which creates a simultaneous spectator-participant, is gratifying: the art historian Marsha Meskimmon writes: "Soft fabric caresses skin, warm light and shade play over the body; there is an ease of pose, a playful reverie enacted in these images and they invite a fully-sensory engagement, a visceral understanding or empathic feeling of comfort and gentle pleasure in our bodies as we look at them."[3] That engagement, she understands, involves the spectator-participant in "a critical entanglement at play here, as these photographs materialize a body and a beauty that have survived life-threatening illness."[4]

We see survival of the body and beauty too in the book *The SCAR Project,* published in 2011, whose subjects from eighteen to thirty-five years old, photographed by David Jay, are women after breast cancer treatment, including mastectomy.[5] Depicted in one photo each, the women appear sad and the book evokes tragedy. Granted, breast cancer diagnoses and treatments when a woman is younger than forty carry burdens that impinge differently on older women or do not affect them at all: sexual self-esteem, the ability to nurse, untimely menopause, and four or more decades to worry about the possibility of cancer returning. *The SCAR Project* leaves an impression that its subjects have persevered and pulled through. They have overcome, even the body itself, whereas *Self-Evidence,* in Meskimmon's perception, "is not work that . . . overcomes the body, but moves forward, becomes, in the full weight of embodiment or, as Frueh puts it, the 'joy of soul-and-mind-inseparable-from-body.'"[6]

ART WORKS LIKE A DREAM. It puts images into action, serving to encourage and strengthen one another, so that people enter into community. The heart is the master of such effects.

A gesture of my friend Robert Lostutter, a master painter whom I've loved since my twenties, located that reality for me during a conversation on June 29, 2015. We always talk about art and he said, "Art comes from here," as he placed both hands on his heart. From the heart, in and for beauty—those locales of creation produce combinations of joy, meditativeness, and self-reflection, which may feel pleasurable or harrowing, and both at the same time. Art comes from the heart and awakens it, and the experience can thresh us to the marrow.

Self-Evidence may repel someone, and that is no less an awakening than is a kinesthetic contentment. Frances told me of a fellow photographer's reaction to some of the *Self-Evidence* photos. They've been acquainted since the 1970s, and the work repulsed the woman. On the other hand, a differently sensitive friend of Frances's, on experiencing a photo in which I'm pictured from neck to upper thighs (with the lacy tops of stay-ups prominent), chest exposed, and holding a dark purple pansy, observed, "It's sacred."

Frances describes the sacredness of art with the word *anointed.* She can feel anointed when taking photos: "The hairs stand up on the back of my neck. Something is happening in the room and all of a sudden I feel joy and radiance—that moment when the presence of the universe is clear." In that moment, the heart thrives.

ART ENABLES THE JOINING OF PEOPLE in a community of power—power that helps them feel whole, connected with one another and the universe. Art is a healing, coalescing dynamic, and in practical and poetic ways it satisfies an unvoiced longing for community.

Women and girls hunger for a true community of beauty. They live today in an isolating and corrosive beauty world, where they compete

with one another to be the most beautiful according to crazy standards, where the power of their own colors and shapes and those of other girls and women are underappreciated or dismissed, where acceptance has shattered into an anarchic pain of remoteness from the genuine fearlessness of our hearts. The in-your-face bravado of celebrities who show off anatomical and facial features that media and the entertainment industry shove in our direction veers away from the heart's genuine fearlessness, and we witness the lionization of a homogenized and costly beauty bought through surgical and dermatological procedures, private workout coaches, and stylists' magic.

Our unadulterated hearts: they are the creative source of women and girls as artists of themselves, as artists of a community of beauty.

Standing outside of the beauty culture is nearly impossible for any female today in the United States, and ever more so globally. Frances and I witness the crises that women and girls suffer in their efforts to be beautiful, and we are painfully cognizant of how criteria for female beauty have escalated into a kind of insanity during our lifetimes. Frances sees this firsthand with her twin daughters, who are in their forties, and her teenage granddaughter. I hear it in close friendships with women from their twenties into their late seventies and in passing moments with acquaintances and strangers, and my scholarly and artistic focus on personal beauty has entailed extensive research into the beauty culture in which I live and pointed observations about it.

Frances and I are elders now. We feel that we would have been arrogant to embark on this project when we were younger. At our age, inessential elements of life and art slough off, and a retrospect of experience gives our work, both collaboratively and individually, the immediacy, import, and vibrant freshness of *Here's what really matters*.

Culture's BREASTS I

"IT'S A BOOBCENTRIC CULTURE," proclaimed a young friend of mine. Boobcentricity turns flesh into fetish—obsession, fixation, mania. A fetish is an *object* of power, so fetishization separates the breast from its natural home, the female body, and fabricates it into a *thing*. As such it is a symbol, a dream, and a commodity.

The inanimate breast is big, high, and mighty in the American imagination, an icon of femininity, sexual attractiveness, and womanhood itself. Our boobcentric culture drives women to want "better" breasts than their natural ones—larger, perkier, fuller, and more shapely, in order to satisfy a dream of bodily perfection that features the fetishized breast. Body *dys*phoria, the evil flower of boobcentric *eu*phoria, flourishes in the fertile soil of breast mania, which *conditions* a desire to emulate the current archetype of mammary bliss.

Females' embrace of their own breasts as erogenous, giving pleasure to women and girls *themselves,* is irrelevant in the boobcentric culture. Within boobcentricity, the actual function of the breast, to feed an infant, vanishes from consciousness. However, the love and nurturance that define mothering surely sustain the agog sexualization of the visually

adored breast; because in a world that is searingly and sordidly out of touch with nature and its plentiful provisions, that is sick for the intimacies and affections of love, a mothering breast is filled not only with milk but also with utter benevolence and comfort. Who doesn't want those?

Despite the fact that breastfeeding in public is not forbidden in the United States, a woman who is nursing may be harassed for doing so, such as being asked to leave a restaurant. (In other circumstances, revealing a female nipple *is* illegal.) The fetishized breast is *abstract,* a fantasy, and people imagine kissing, caressing, and sucking it during lovemaking, while girls and women picture their own form matching the dream anatomy. In a restaurant or an office or a park, a nursing mother's breast is *real* (even if covered), as is her relationship with her child. Real flesh, real love: they are the taboos.

Archetype and accessory. Those are the polar performances of the fetishized breast. Like high-heeled shoes, a sister fetish that conveys female potency, breasts are fashion items. They can be styled, not only by bras but, more profoundly, by surgeons. Both high heels and breasts offer their designers sculptural opportunities, and some women envy a great pair of shoes or a great pair of breasts.

Bras give support and uplift. So do breasts themselves. Which may be why the breast that energizes dreams and surgeries is literally as well as figuratively elevated. An elevated breast is a cheerful breast.

The body is a dreamhouse, though people see it as a house of cards. A precarious place to live, where *All fall down* seems to be a fact. Dreams build the body—constructive imaginings and imaginative reconstructions about the "house" into which one is born. With materials ranging from food to thoughts, whatever we ingest, we dream our comfort, security, and beauty, and sometimes we dream the worst, such as accidents or dread diseases. In the dream of breasts, women's fears about downward drift, the chest of a hag, collide with visions of upward lift—that our breasts be beautiful, well, and loved, that they give pleasure to ourselves and others.

BREASTS AS WEAPONS. The bullet bra redux by Jean-Paul Gaultier for Madonna's 1990 Blond Ambition Tour. Invented in the 1940s and popular in the 1950s, bullet bras emphatically emphasize breasts by giving each one a cone-like shape that is especially evident in sweaters. Another name for bullet bra is torpedo bra, and it is still available. Its severe reshaping of the natural breast can be seen as a voluptuous exaggeration or as an extreme and rather comical distortion.

"I got a rocket in my pocket," sings rockabilly performer Jimmy Lloyd in an eponymously titled song, recorded in 1958, that he cowrote. Analogously, a woman might have hooters as shooters.

A young woman with blonde waves and curvy lips points a handgun at us from the cover of a 1946 pulp novel, *Don't Ever Love Me.*[1] She holds the pistol just above her bullet-styled breasts, which point from a low-cut gown as red as the color of her mouth. Her look means business: stay away. But her beauty entices. She is the femme fatale, at once desirable and dangerous.

Bullets and torpedoes stock the arsenal of femininity.

BREASTS DRESSED FOR SUCCESS. They appear in a Maidenform ad campaign that ran from 1949 to 1969, the formative years of my femininity. "I dreamed" begins the shrewd, pivotal copy in each ad, launching us into an inspiring variety of activities and identities, and the sentence ends with "in my Maidenform bra." The female figure in the ads truly stars in them. (Infrequently, the spotlight is on more than one figure.) Her costume varies, her bra is the intended focal point of the ad, and she emits an elegant and often breezy allure.

Let's enter into the powers and pleasures of the Maidenform woman: "I dreamed I . . ." had the world on a string, was a toreador, was bewitching, went to work, opened for the World Series, was the Queen of Hearts, won an Academy Award, rode a roller coaster, went square dancing, walked a tightrope, had spring fever, went on a safari, won the election, swayed the

jury, was a work of art, played chess, made sweet music, was a medieval maiden, played in an all-girl orchestra, was a fireman, covered the Paris collections, was a siren, was a classic beauty, was tickled pink, went strolling, stopped traffic, went back to school, was a private eye, barged down the Nile. That is a sampling of her triumphs and adventures.

The Maidenform woman is dashing, confident, and full of fun, wit, and self-respect, sexy, and a little provocative sometimes. She gets things done, enjoys her own company, and uses her intelligence and creativity.

I can critique the campaign, for over-the-top romantic nonsense and propagation of standard beauty. If the heroine of the campaign did not *have* a maiden form, young, slim, and buxom, her success in work, adventure, and play could not have been sold. And of course, the ads are ridiculous—honestly, a woman in her underwear on a tiger hunt or presenting an argument in court—and occasionally even weird and creepy: "I dreamed I was a Jack-in-the-Box" and "I dreamed I was ogled by creepy clowns."

Nonetheless, breasts dressed for success built joy within the dreamhouse that is my body.

I dreamed, I dreamed, I dreamed.

A WOMAN CAN MAKE A LIVING from her winningly sized and shaped breasts.

Jane Russell became famous for her breasts when she exhibited them underneath a thin top in *The Outlaw,* which was her film debut. According to Russell, she padded her bra with tissue and pulled the straps up to raise her breasts, thus achieving an ideally buxom look with her 38Ds. Released in 1943, *The Outlaw* began Russell's Hollywood celebrity, from the 1940s into the 1950s. Born in 1921, she became the star of television and print ads for the 18-Hour Bra in the 1970s and 1980s, the spokesperson for a Playtex product. Russell's breasts: glitteringly commodified in her youth, then more mundanely useful to commerce itself after she aged out of the early mythic glamour that clung to her enough so that she could promote bras.

In the marketplace of dreams, breasts are bought and sold. Augmentation, lift, reconstruction, reduction, and revision are the procedures offered by cosmetic surgery. All are very invasive, 9 to 10 on a scale of 1 to 10, and they are painful, 6 to 8 on the same scale.[2] Good thing that permanence also ranks high, 7 to 9.

I heard from a friend about two husbands who did not want their wives to have reconstruction after mastectomy because of the pain involved. The wives went ahead with the procedure.

Breast surgeries can contribute to a woman's sense of bodily, psychic, and sexual wholeness and they can also cause discomforts and problems, immediately after surgery or over the longer term. Some of them are lack of full sensation when breasts are touched (by oneself or another); permanent numbness down the inside of the arm; infection; fluid buildup; replacement of implants ten to fifteen years down the road; hardening of the implant; lack of symmetry. A variety of other failures are possible.[3]

Despite big-boobcentricity, breast reduction is a blessing for some women. Large breasts can cause back and neck pain, their weight is uncomfortable, and so are the bras, which a friend with large breasts calls harnesses. She showed me the grooves that they make in her shoulders. My friend is Frances, whose breast surgery in autumn 2015 reduced her D cup to a B. She loves the results. Interesting and a little amusing to me that her elective surgery and my medically chosen one decreased our breasts by the same amount. I went from a B cup to an unlettered equivalent of 0.

Still, some women can't be big enough. A drastic example is a woman whose surgeries gave her a 34FFF, which did not satisfy her dream. Neither did 38KKK.[4]

BREASTS ARE A UNIFORM OF FEMININITY and femaleness. A primary identifier and universally recognized as such. That trans men don't want breasts indicates their telling femininity.

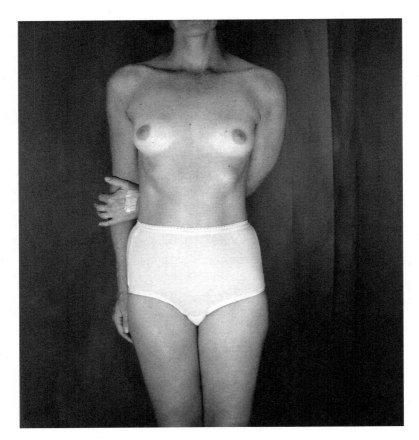

WHITIES, 1985

If a woman does not "wear" the breast uniform due to mastectomy or in anticipation of augmentation (for some trans women), she may feel miserable, ugly, inadequate, and defective. Others may assess her similarly. A friend told me that her father said to his wife after her bilateral mastectomy, "Now I don't have to worry. No man will ever look at you again." I asked my friend if he was joking, and she said, "No."

The uniqueness of breasts differentiates them from the breast as dream and symbol. Uniqueness upon uniqueness. Billions of breasts in today's world, an infinitude of breasts since the beginning of *Homo sapiens.* Zillions of shapes and boundless personal passages through lives lived in bodies with breasts.

Breast Permutations (1972) by the artist Martha Wilson is a black-and-white photographic grid of nine pairs of breasts. They range from pretty flat to quite large, and their shapes vary from conical to spherical to pendulous. Areolas differ too, from petite to goodly, and we see nipples that point anywhere from sideways to directly forward. The utter uniqueness of nine pairs of breasts represents the reality of zillions.

Culture's BREASTS II

BEAUTY APPEARS NOT TO CROSS THE MINDS of women under-going a breast cancer experience. Frances and I asked both a breast surgeon and a medical breast oncologist, Dr. Leona Downey, as research for this book, "How do you address fears about beauty?" Their responses indicate that beauty, while not brought up directly by patients, is buried within stated concerns. In this chapter I refer to Dr. Downey as Leona. Our interview with the breast surgeon was conducted in person and confidentially, so I refer to her as "the surgeon" and obscure some details of her career.

Frances and I interviewed the surgeon in October 2014, and the information and quotes from her all date to that meeting. Leona responded in March 2015 to an e-mail questionnaire that Frances and I composed. When Leona moved from Tucson in June 2015, she ended her practice. Statistics and information about her and it come from her e-mail response.

The breast surgeon began to focus solely on breast surgery at the beginning of this century, when she was in her late thirties, and mentions that not many doctors choose that specialty. "I take pride in someone living well," she says about her self-described perfectionism. Leona, who helped

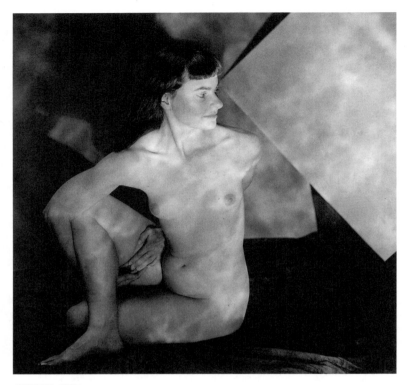

ANGLES, 1987

me through turning points in the breast cancer experience, chose her specialty in 2005, when she was twenty-nine, and like the surgeon, she did so because "it truly allowed me to make a positive impact in the lives of many."

The surgeon said that most of her patients "don't think about beauty," but she observed that "30 to 40 percent don't even think about living without breasts or never thought they could," and "having breasts is simply obvious" because "they want to feel complete." From what the surgeon reports, it follows that feeling complete is feeling normal: a normal woman has breasts, which feels good; so breastlessness or an oddly shaped breast after lumpectomy are abnormalities that feel bad, in part because in many eyes they look bad—in other words, ugly. Starkly put, the coin of appearance has two sides: good looks, which is beauty, and bad looks, which is ugliness. So at the risk of overstating the ubiquity of women's absorption with beauty, even when it is unconscious, thinking about one's chest after breast cancer surgery, whether mastectomy or lumpectomy, is thinking about beauty. "How will I look?" (Without a breast? After radiation or a lumpectomy?) carries within it "Will I look normal?" which implies "Will I look good?" and that is a question about one's beauty.

Leona didn't bring up the "topics [of beauty or body image] unless the patient does," which is atypical, but she thought that they were "immensely important to the woman recovering from breast cancer treatment, and a push should be made to address them in survivorship. There is a big movement toward survivorship, and more formally addressing things that are important after or in addition to the traditional treatments of surgery/radiation/chemo/hormonal therapy, like bone health, diet, exercise, maintaining healthy weight, and issues of body image, needs to be highlighted here."

Physical health and body image, or beauty, are cogently related. Mental and emotional well-being belong to that picture in terms of the vulnerability that fear about one's lack of beauty may arouse. Breast cancer can be a doubly grievous wound, traumatizing to the psyche as

well as the body. In Leona's words, "Some patients have told me that they will not allow their partners to see them unclothed after breast surgery." In general, she found that "many women are afraid about how their body will look after surgery," and being comfortable with their bodies after surgery is not 100 percent. "I would say 75 percent are 'comfortable' with their bodies after breast surgery, but that a smaller number, maybe 50 percent or fewer, are truly happy, or embracing of their bodies after surgery." Embracing her changed body after breast surgery includes a woman's being satisfied with her appearance, feeling that she looks good.

UNIQUENESS UPON UNIQUENESS characterizes women's experiences of breast cancer just as it does the real appearance of women's breasts unto themselves. Besides living in a culture of breast fetishization, each woman lives in her very particular family and friends environment. Her physical and psychic health going into and through the medical situation are hers and hers alone, and while her emotions may be similar to those of other breast cancer patients, individuals are indeed exactly that, so the nuances of faith, hope, fear, and self-love or -loathing are not only specific to every person, but each of the above aspects inflects the others in ways that are never before seen and unrepeatable.

Breast cancers differ from one another, in tumor size, in whether the cancer is invasive or noninvasive, and whether it has spread to lymph nodes, bones, or organs; and the combination of diagnosis and prognosis determines surgeries and treatments—lumpectomy, mastectomy, radiation, chemotherapy, medications in pill form taken for years after the diagnosis—or a woman's choosing none of them. Two or more women may have similar diagnoses and treatments but their transits and outcomes may differ a good deal from each other's.

MASTECTOMY CASTS A PALL on the emphatically feminized breast. Especially bilateral mastectomy. It can toss women into a gender quandary.

In anticipation or in the aftermath, dread of a culturally devalued body may ensue, whether or not a woman intentionally thinks about her aesthetic or erotic status. Am I feminine? Am I neutered? Am I a woman? Am I incomplete? Who am I, anyway?

A surgeon severs breasts, but a woman may feel severed from the comforts and familiarity of her most intimate home, the body. Reconstruction may ease homesickness. Some women love reconstructed breasts and others don't. The very things that produce one woman's happiness and contribute to her mental and erotic well-being may turn off someone else.

A woman who underwent a unilateral mastectomy and replaced the removed breast with a bigger one while also enlarging the healthy breast so that both sides would match raves about the result in an article she wrote for the AARP magazine. Enraptured with her 32Ds, she vaunts her pleasure in her prose: "Do my new breasts look natural? Hell, no. They look better than natural."[1] This Baby Boomer woman[2] "forever envied more voluptuous women, i.e., virtually every other female on earth," and now "my husband says that if he closes his eyes, he feels he's with a 25-year-old."[3] She seems revitalized and saucily indicates that her sex life with him is improved. A reader might exclaim, "Hurray for techno-breasts!" Another might like her beloved's eyes and heart open to perceive her as she is, at whatever age and however her chest looks.

Some women want to remain as is after mastectomy. They feel that reconstruction is a denial of reality; that surgically assembled breasts are an artificial and therefore unwelcome beauty; or that they've had enough trauma to body and mind and don't want to prolong healing and recovery. Insurance that covers mastectomy also pays for reconstruction, which eases financial pain, but the reconstructive process can extend for months, and I've heard women say that it was the most physically punishing part of their breast cancer experience, more so than surgery, radiation, or chemotherapy.

"A patient who had a unilateral mastectomy said she was not going to have reconstruction," Leona told me, "stating that she felt great pride in her mastectomy scar, knowing it was a sign that she came out of the experience ahead, having 'beat' the cancer."

The surgeon offers reconstruction to every patient along with the information that reconstruction comes with more pain and more risk of infection. The majority of her patients choose reconstruction—all of them in their thirties, 95 percent from forty to fifty years old, and 30 percent to 40 percent in their sixties. She wonders about her reconstruction patients: "Do you know what you want? These are manmade, and women scrutinize them like they don't or didn't do with their real breasts." Such scrutiny arises with the ability to choose size and shape. Women older than fifty may feel that having breasts is not a female duty, so they forgo reconstruction, whereas young women may feel that new breasts ground them in the sexual and beauty realities of their peers. A young woman may miss her breasts more than an older woman, who has lived with them for many more years, often most of her life.

A friend who had two reconstructions after a bilateral mastectomy in 2010 at age forty-five took them as opportunities. I admire her practical aesthetics: "Boobs: if you must change them, then make them what you want," she told me in an e-mail in 2015. (She wishes to remain anonymous.) The first time, she chose breasts a little larger than her original ones. The second time, in 2014, when "the internal sling holding the implant had dete-riorated and the implant shifted," she chose "a teardrop instead of a round implant. I think [the breasts] are more shapely and I like the fullness."

I saw around fifteen women show their reconstructed breasts all at once in 2012. They did it to brighten up a woman among them who was undergoing a drawn-out reconstruction process. The breasts looked lovely in their individuated shapes and sizes. However, my close friend, who had not undergone a breast cancer experience and was standing next to me during the display, said when I asked for her response to the

surgically built breasts, that they paled in comparison to real breasts that a person knows and loves, such as a mother's, sister's, first lover's, or one's own. The reason is that the sensual, emotional, and metaphysical resonances of actual, organic breasts were missing. Extending her response, the reconstructions felt lifeless—flat.

Without taking any of the above observations or data as be-alls and end-alls, we can gain insight into ourselves through them, whether or not we have had a breast cancer experience, and into women we know who have journeyed through one. Where do I fit into these stories and facts? How do I understand the choices made by my mother, cousin, lover, wife, or best friend? can be penetrating questions whose answers underlie the meaning and value not only of breasts but also of the mesh of health, beauty, and self-criticism and -acceptance in our and others' lives.

Maybe reconstruction is a medical-aesthetic miracle and maybe it is "technological exhibitionism."[4] Maybe reconstruction is make-believe and maybe it is a consolation prize. Maybe reconstruction is about the past and the future more than the present. New breasts as a memory of what was and a wish for what will be, filled with happy associations of attractiveness and sexuality, of health. New breasts as a promise of fetishized perfection, because a woman can choose a different shape and size from the originals. New breasts to erase reminders of a breast cancer experience, both visibly and psychologically. New breasts as nostalgic replacements, utopian fantasies, and not only assurances but moreover tributes to remaining alive.

Maybe new breasts are a blessed and most basic renewal—resurrection! of soul-and-mind-inseparable-from-body.

"I ALWAYS HATED MY BREASTS. Not the way they look but the fact they existed," a friend who self-identifies as a "transboy" tells me in an e-mail. "Boy" because of a "less than imposing stature," she teases, and when I ask what pronoun to use to refer to that boy, my friend, who wishes

to remain anonymous, shows again the genial yet acute humor that deliciously startles me, suggesting "he, she, they, it," because pronouns are "irrelevant." Taking her perspective to heart, I use those pronouns (and their possessive forms—his, hers, theirs, its) throughout this section, and I italicize them for the sake of clarity.

Gender is a key aspect of *its* harrowing breast cancer experience, gender thoroughly entwined with choice and the visual. Just as people who feel comfortable being both feminine and born into a female body may suffer damage to their gender during breast cancer treatment, so might a transman who, like my friend, has had neither hormone therapy nor top or bottom surgery in order to look and feel male. "I hated being treated as a woman having a woman's disease," *he* reveals. "So I could not pretend that I was beyond gender." My friend's story reminds me never to underestimate gender when individuals make choices about the visual reality of their breasts—the breasts that they have and the ones they do or do not want in order to feel at ease in soul-and-mind-inseparable-from-body.

Lumpectomy, mastectomy, reconstruction, no reconstruction, top surgery: any of those choices comes not only from a person's surety about her or his gender but just as much from culture's implications and enforcements about breasts as a uniform or imposition of femininity. I am not saying that people are dupes of culture but, rather, that it informs our choices at internal depths into which an individual rarely wades. Culture also informs medical offerings. Breast cancer is indeed a horrifying medical diagnosis, but it can also threaten one's gender status.

Diagnosed with cancer in one breast in 2013 at age fifty-six, the same friend had a mastectomy with "immediate so-called reconstruction. Then the implant got infected and I had to undergo emergency surgery to treat it six weeks later. Thank the Goddess the 'treatment' involved removing the thing." When, following protocol right before the procedure, the surgeon checked with *them* to see precisely what to do, my

friend surprised the doctor with, "You are going to remove the fucking jellyfish." *It* had not realized till then how angry *she* was that *it* had permitted an implant to be placed in *their* body.

My friend wonders if a sticking point in *her* experience was "the visual, feeling incapable of moving over to visual-me"—from the terror-propelled wanting the cancer out to making choices that equally considered *her* health, appearance, and gender. *She* wonders if that inability "may have made me refuse to make 'choices' and deprived me of the possibility of pushing other decisions as choices." Choice—the patient's choice—is of major importance during a breast cancer experience.

My friend said to the surgeon, "Take them both out, please," but that "was never heard. I discovered later the sacrosanct principle of 'Surgeons do not touch healthy tissues,' which I found ridiculous to begin with and then preposterous when the plastic surgeon I met with to see if he could indeed consider that option repeated it. For a plastic surgeon, I thought, this should be a joke." In the United States, contralateral mastectomy, removing the healthy breast when cancer is in only one breast, has been on the rise. I don't know what the situation is in the European city where my friend lives and had *her* experience. In what I've read, common reasons for having the contralateral procedure do not include transmen diagnosed with cancer in one breast who want to have the other one removed in order to feel more whole as a man.[5]

"The surgeons seemed to wonder why I hesitated," my friend explains. "It was good news that I was offered reconstruction immediately (at the same time as the mastectomy) since it probably (unknown to me at the time) meant that I would not have any other treatment. I remember sitting down with a friend and making lists of pros and cons knowing full well, with the instinctive side of my mind that I wish I could trust more, that I did not want an implant. Because when, for your whole life, you have tried to hide, band, ignore your breasts or fantasize that they don't exist, the last thing you want when one is going to be 'missing' is to have

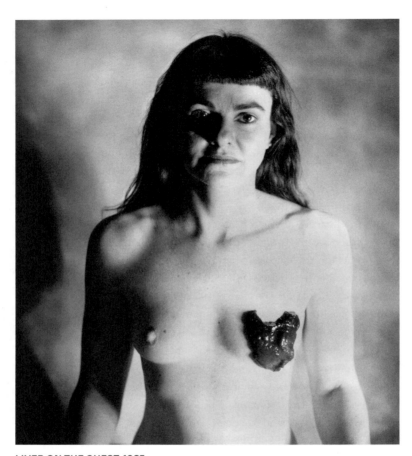

LIVER ON THE CHEST, 1987

it reconstructed in plastic. That seemed like such cruel irony. But no one seemed to hear that." After the reconstruction, "the worst part," my friend remembers, "was looking at this fake bulge that actually looked normal if I saw myself in the mirror. There was a time when all I could think about was to go to Thailand and get the other one removed. My breasts were never eroticized zones, and the one that is 'left' is even less interesting than before."

He describes living with the implant as "horrible," "awful": "I felt like a monster." Though I love my femininity, I would have too.

How little a visual trauma to the breast—lumpectomy, mastectomy, reconstruction—may change women, yet how different they may become. The new chest intersects with personal and public relationships, it affects the choosing and purchase of clothes, and it informs a woman's vision not only of herself but also of herself in the world.

AFTER MASTECTOMY OF HER RIGHT BREAST, in 2011 at age sixty-two, Ilene Susan Fort, who did not have reconstruction because she is highly allergic and didn't want the implant to cause an allergic reaction, realized that the surgery influenced her self-image: "I can no longer buy certain styles of dresses and blouses since my surgery marks and lack of a real breast would be too obvious," she notes. However, "I am still the same person, personality-wise, and still consider myself a proud and accomplished woman." Fort is senior curator at the Los Angeles County Museum of Art.[6] "Still," she says, in a perception of the present self unchanged from the past one.

"I TRY TO FOCUS MORE ON MY INNER SELF and the way I am acting. Sometimes it's really difficult," reflects Jessica Zarling, a thirty-seven-year-old who teaches grade school in Tucson and, almost two years after a breast cancer diagnosis in 2013, was in the process of reconstruction following a "strongly recommended" double mastectomy. Diagnosed with

cancer in one breast, women in their thirties commonly choose double mastectomy because a risk of cancer in the second breast is very high. "My surgeon did a wonderful job and I wanted to show everyone," she says.[7]

Six weeks after the surgery, she "felt good, a little self-conscious. I wore button-up shirts more often than before." A few months later, she noticed being "uncomfortable sometimes clothes don't always fit the way I would like them to," such as tops with "boob pockets." She was feeling "stronger and yet more vulnerable, like I can do anything and yet I'm scared to death about everything." If strength and fragility ever seemed to be contradictions, they may seem compatible, like two sides of a coin, when a woman sees soul-and-mind-inseparable-from-body through a watershed precipitated by her breasts.

"PHYSICAL APPEARANCE WAS SO IMPORTANT to me after surgery. Now I'm not as concerned," discloses Donna Levinstone in a November 2014 e-mail.[8] Levinstone was forty-four in 1999 when she was diagnosed with cancer in one breast and had an implant inserted at the time of her mastectomy "with a skin-saving procedure. It was a Latissimus Dorsi Flap Reconstruction, where skin and muscle were moved from my back to reconstruct my breast. The nipple was tattooed and sculpted in an attempt to match my other breast. Today I am sometimes a little self-conscious that one breast is bigger, as menopause enlarged it, and my reconstructed breast stayed the same, and it's firmer, the 'Hollywood Boob,' my husband calls it. But the tattoo has faded along with my need to have a perfect-looking breast. The scar on my back used to bother me. Now I wear it like a warrior. I can even parade around nude at a communal spa!" Levinstone describes old and new visions of herself, which cohere in fadings of color, apparent necessity, and awkwardness that yield growth into self-regard and service.

An artist and native New Yorker, Levinstone is "happy to give back" after realizing through her breast cancer experience the shocking

tenuousness of life, and she equates that derangement of the ordinary with everyone's exposure to it on 9/11, which occurred right after she completed chemotherapy. She now works with "cancer survivors teaching art and hopefully making their lives a little brighter. Also, my artwork is placed in hospitals, providing beauty, serenity, and healing." Her pastels and prints of landscapes and ocean views feature vast skies, heavens really, whose subtle shifts of color and emotion move the viewer into transcendent spaces, represented as physical realities but, just as important, epitomizing the spiritual spaciousness within human beings.

PERFECT BREASTS FOR PINUP MODELING OR PORN, two of Annie Sprinkle's professions on her career path as a sex worker, sex educator, and photographic and performance artist, changed not only because of age but also because of three lumpectomies, two directly after a cancer diagnosis in 2005 at age fifty. The third "came a few years later to take out a fatty tumor. No reconstruction. The breast that had the lumpectomies is definitely smaller, but most folks would never know."[9]

Sprinkle's attitude toward the cancer, the imperfect match, and the fact that her breasts are "pretty droopy, but at sixty that is relative" is her characteristic down-to-earth and happy-go-lucky one, apparent throughout the range and genres of her art. "If I had to get a disease, I was glad it was boob-related, as it fit into my longtime body of work. My response was, gee, this is going to be interesting and exciting. Something new to do!" This from the artist who created *The Bosom Ballet* (1991) and more recent "tit prints"—her term—in which the "two sizes are pretty clear." *Bosom Ballet,* a grid of nine black-and-white photos, shows Sprinkle, from neck to navel, displaying and playing with her naturally generous breasts.[10] Black opera-length gloves lend graphic drama to the dance. One tit print on view on Pinterest features Sprinkle's pigment-covered breasts pressed against paper to form the shape of a heart, and her left one does look smaller than the right.[11]

As Sprinkle says, "I was not concerned, wasn't fussy about what my breasts would look like" after the lumpectomies. "I think having been a pinup model and having made a lot of porn, I felt good about my body, and I had documented it well and enjoyed it to the hilt. So I welcomed whatever was coming next." She clarifies that outlook, which includes her and Elizabeth Stephens, her partner at the time (now her wife) making the breast cancer experience "fun. But I was only Stage 1. So we had the luxury of doing that, and we laughed a lot. Good coping strategy!" Stephens is a professor of art at the University of California, Santa Cruz, and she and Sprinkle created many collaborative artworks during the breast cancer experience.

Sprinkle is "still enjoying my breasts." One way is that her actions on behalf of her breasts during the breast cancer experience became activism. "I am really enjoying my ecosexuality. Getting cancer led to my . . . work in ecosexuality. I learned about how our polluted environment is causing so much disease, and became more concerned about environmental issues." Sprinkle and Stephens "usurped the word" *ecosexual* from the dating world.[12] It was a term, "like metrosexual or heterosexual, or bisexual. . . . we decided that ecosexual would also mean being lovers with the Earth. I don't think people had been using it in that way. And we invented the term sexecology to create a new field where one explores the places where ecology and sexology intersect."[13] Sprinkle's personal experience directed her into a new passion that integrates with her previous work and expands to include the planet itself.

SAMA ALSHAIBI IS A MULTIMEDIA ARTIST, born in Iraq to a Palestinian mother and Iraqi father, who documented aspects of her breast cancer experience. She chose a bilateral mastectomy with reconstruction after being diagnosed with cancer in her right breast at age forty in 2013, an aggressive action because of having seen many friends and family die of breast cancer. Alshaibi is a professor in the School of Art

at the University of Arizona.[14] Although Alshaibi often appears in her photographic and video works as one of their beautifully dramatic and striking aspects, "I am not someone who normally takes off my clothes in my work," as is not uncommon in the art of contemporary women visual artists. "I am a Muslim, and feel I should only expose my naked body if the work requires it," and the breast cancer experience did.

The configuration of traumas and vexations that Alshaibi so passionately felt during the breast cancer experience gives insight into a lavish inner transformation that benefits her family and will aid other women who are undergoing a breast cancer experience. She withstood seven surgeries in six months, six for infections in the right side beginning three weeks after the mastectomy. She lived with an expander in each breast for far longer than the usual three to four months, because she accepted a Fulbright to Palestine. (An expander, a temporary implant placed between the chest muscle and the skin after removal of the breast tissue, stretches the skin to make room for the final implant.) "There was no way I was going to stay in America over better breasts and lose my opportunity to be in Palestine for a year with the Fulbright." She sustained opposition to her desire for reconstruction: "It was annoying that a few of my *male* feminist-minded friends, and survivors who I met, wanted me to reject reconstructed breasts. They were disappointed in my wanting breasts and felt that I had not taken on the 'cause.' Whatever. I wear lipstick, high heels, and also wear combat boots and dry my hair naturally. I hate when others impose their idea of beauty and strength on women through their own vision of aesthetics and power." And she and her husband were resolving problems that started before her diagnosis and for which they were seeing a therapist: "We were just getting to a good place when I found I was sick. We were on that track to solve our issues together, and cancer could have broken everything." They continued therapy through the months of surgeries.

We feel Alshaibi's fervid self-awareness too when she reveals a connection between the anguish of breast cancer and her choice of

reconstruction: "Mostly it was not having to live with the reminder of loss. You lose so much more than your breasts when you have breast cancer I didn't want such a huge reminder every day about what happened." Small of frame and breast size while also muscular, Alshaibi did not want to "'restore' what I had before, but all my life I've really loved the way breasts look on women." She chose a larger size for both breasts, "which were drooping after I nursed both kids," and she thinks that her "breast size now fits more in proportion with my body. But I would have never changed my breasts had it not been for cancer. I was always happy with who I was. This is just different me." Different on the surface— visually—and different deep down.

Deep-down-different me declares, "I enjoy being imperfect." What a statement in a world that drives women to seek perfection in their appearance, work, and domestic lives. "I feel better about myself. I am more sure of who I am as a woman, and what makes me a woman, but more importantly, a human being. I was always athletic, ate super well, and was doing practices that are safe for being healthy. But now I sleep more, I put priorities about my art practice, travel, family life, and teaching in an order that is far more sustainable. I forgive myself and others easily. While I wish breast cancer on no one, myself included, I can only be honest by saying I would not be willing to go back to who I was before. The best thing is how close I have become with my husband and children." A breast cancer experience pushes against a woman's habits, and when she yields to changes that she perceives have created a "better person since breast cancer," love, larger than ever, may emerge as the greatest fortune.

Alshaibi, the "different me," from that deep-down power of self-recognition, pictured her visual self, not only on her iPhone, including one-breasted in a sundress, but also by her best friend, the artist David Taylor, her colleague in the School of Art, whom she asked to photograph her topless with her original breasts and wearing a skirt. With those

mutual photos, Alshaibi wants to pierce through the shame, silence, and stigmas in the Middle East regarding women's breast health. "The United States is just barely breaking down barriers. In the Middle East, women's health is a joke. I want to make work that intersects my own story with the travesty of what is happening there. Nursing in public there is normal, but care for the breasts (and reproductive organs) is pathetic. Married and not, women face impossible situations." In the Middle East, more young women tend to suffer from breast cancer than in other countries, and when diagnosed, breast cancers are often late stage, making mortality rates from it higher than in the Western world.[15]

BREASTS MAKE WAVES IN A WOMAN'S LIFE. While their cultural fetishization can undermine her confidence, a diagnosis of breast cancer upends her world, engendering simultaneously physical and psychic changes whose permanent potency one's soul-and-mind-inseparable-from-body can never forget. A woman's remembering in itself makes waves, so that a plight beginning with breasts may refine her conscious participation not only in daily existence but also in conditions great distances away.

Passion for her breasts and compassion for herself may coalesce into an ardent compassion well beyond a woman's personal life.

My BREASTS

BREASTS LOOM LARGE in the human imagination, but they never have in mine. I was aware of the looming-breast phenomenon beginning in early girlhood, and I remember being perplexed by breasts that stood up like cones when some glamour girl was lying on her back in a movie—the obvious unnaturalness. As the adult me can say, an undergarment reshaped those breasts for delectation and spectacle.

Beauty marks, not battle scars. That's what I call the lines left by surgical incisions. Some cosmic benevolence brought that phrase to me during the month between surgery and chemotherapy.

Barbaric. It describes mastectomy, chemotherapy, and radiation.

I've heard *She lost her breasts* as a grim characterization of mastectomy. That phrase arouses an internal laugh from me, and sometimes it turns into an audible chuckle. Lost her breasts—like lost her keys or glasses. On a shelf in the grocery store? At a restaurant where she was having lunch with girlfriends? While talking with her hair stylist? In the trunk of her car? Lost—as if no decision were made. Lost—how mindless. Lost—could she pick them up at a lost and found? Lost—oh, I just forgot about them for a moment and then—they were gone.

My breasts always satisfied me aesthetically and sexually. I enjoyed looking at them and caressing them and liked how they filled out and felt in clothing. All around, they were wonderfully comfortable in size and shape. I wore tops and dresses that ranged from clingy and snug to romantically loose, and I liked the verbal and physical love that both sweethearts and irregular sexual partners gave to my breasts. I wore a B cup and wasn't into comparing my breasts with other women's.

My preference for bilateral mastectomy with no reconstruction was probably formulating in my unconscious from the terrifying moments when a radiologist told my lover and me, as we sat looking with him and a nurse or two at the mammography pictures that had just been taken, where cancer might be in each breast.[1] Through the biopsies and into the morning of surgery, low- to high-level terror agonized me, but doubt about bilateral mastectomy with no reconstruction never did, and it never has.

Simply me, as is. I never considered reconstruction or bra inserts.

My preference might have been different had I been younger, concerned about whether a spouse, sweetheart, or potential sexual or life partner would find me appealing; wanting to replicate my own breasts; or excited to replace them with larger, smaller, or differently shaped ones. My whole body gave me happiness, and my breasts were part of that, so I trusted that the overall corporeal happiness would continue without them. And unlike a woman who is in her forties or younger, I had lived with my breasts for more than half a century. I knew them well, they had provided pleasure for me and for others, and my as-is chest would do the same.

Bilateral mastectomy with no reconstruction was neither a choice nor a decision. It was *there,* like my mother's love. Simply, reassuringly, and completely there. Although I didn't look for reasons why that was so, in retrospect I can share some thoughts about why that preference was clear.

I didn't feel the need of enhancement to an as-is chest, an addition to the body whose familiarity and appearance I love. Prostheses would have excessively accessorized my body, like a huge, ornate handbag or a showy

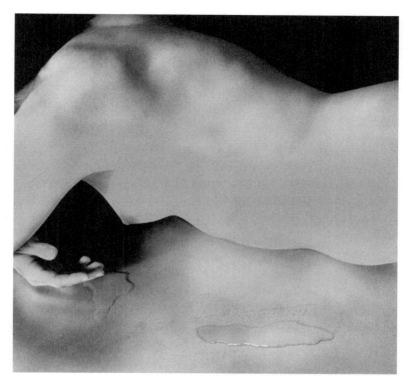

FLUIDS, 1987

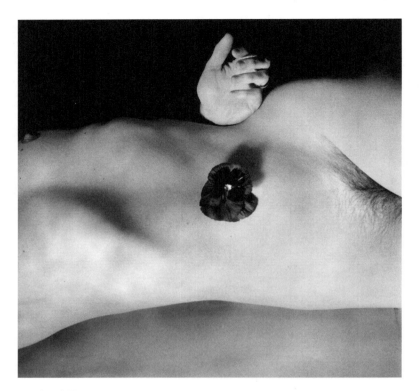

PANSY, 1987

pair of shoes. I love my feminine chic, but a *prosthetic aesthetic*[2] rings false for my soul-and-mind-inseparable-from-body, as an obligatory style of femininity, a compulsory dress code. I am slender and fairly athletic looking—a body type on which a flat chest visually integrates more smoothly than on a stout or stocky woman, whose proportions change more noticeably after mastectomy.[3] I was doing all that I could to give myself peace of mind, and I would have symmetry.

Archetypal, mythic images of beauty and power inspirited me. Amazons: female warriors who first appear in ancient Greek mythology, art, and history. Legendarily, Amazons burnt or cut off one breast so that it would not interfere with the wielding of weaponry, such as bows or javelins. Androgynes: sexually ambiguous figures whose at once masculine and feminine qualities, both physically and psychically, symbolize *human* wholeness. Lucky me, I thought, to be familiar with Amazons and androgynes through scholarly study that began in my early twenties. From then on, I especially identified with bold and gorgeous, femininely styled androgynes in nineteenth-century art and literature.

I AM A MINIMALIST AESTHETICALLY. People use *Zen* to describe my home in Tucson. That I felt neither loss nor mourning about my breasts surprised me the few times when the absence of those feelings came to the front of my mind. Bothering to correct people who presumed otherwise seemed irrelevant, so I didn't.

I wanted to touch my new chest very much as soon as I could during the healing process—the beauty marks, the skin over muscles that asked for rebuilding and nerves that longed for sensation. At first, the lightest strokes—I was scared, about hurting myself, about feeling never returning. The feather touch became confident caresses, and I'm sure that they helped me heal, emotionally as well as physically. Trauma retreated with the primal love of my hands on my own body—a laying on of hands.

My wardrobe is the same as ever, the tops and dresses I have mentioned that range from clingy and snug to romantically loose. I've worn low-cut necklines and a Speedo swimsuit, a black one-piece that's as sleek as can be.

The surgery took place in Tucson's June heat, and I felt uneasy imagining being out and about, several weeks later once I'd healed, in the tank tops that are summer staples for me. Nonetheless, I very deliberately donned sunglasses—I wanted to be able to privately observe people's reactions as much as I wanted to hide my own—and ventured into my neighborhood for early morning walks with my as-is fashion and beauty statement. No one noticed. That was great. I was smiling, so happy to be free as the new me.

No bra, no hindrance to my expanse of chest, which a male acquaintance described as "very sexy" when I told him that I'd had a bilateral mastectomy. He saw me within weeks after surgery, when I was still wearing my typical postprocedure lavender bandeau halter-style sports bra under a sweatshirt with its sleeves cut off and zipped low.

The only people who looked obviously at my as-is chest within a year after surgery were almost exclusively (1) people who knew me minimally but enough to have heard that I'd had a breast cancer experience, and (2) men, whose habitual breast gaze can be expected by the as-is crowd as much as by others.

I returned to intensive weight training the summer after surgery and chose the University of Arizona rec center as my gym. Mostly young men work out in the weight room. I felt a little self-conscious in one of my thin, contour-revealing tops, but only once did I see anyone stare at my chest. I asked one of those young men for help with equipment taller than my reach, and I had to keep from laughing when he looked so hard. His face revealed no surprise, no I've-seen-a-monstrosity, and my curiosity about what he did perceive was short-lived. The rec center self-consciousness quickly faded away.

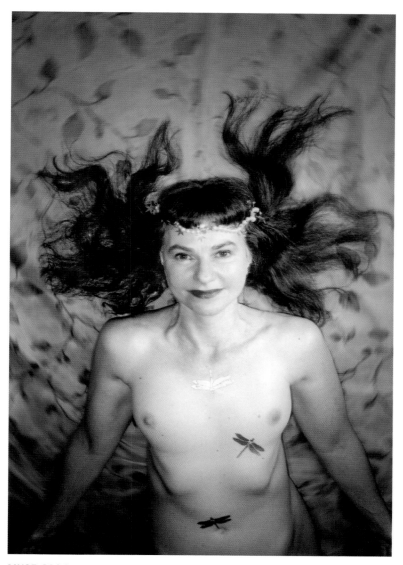

MUSE, 2004

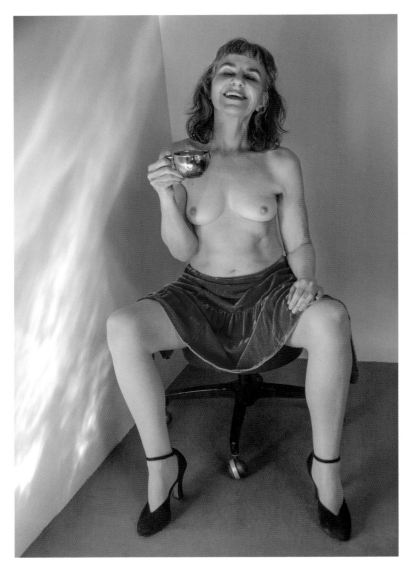

TEACUP, 2012

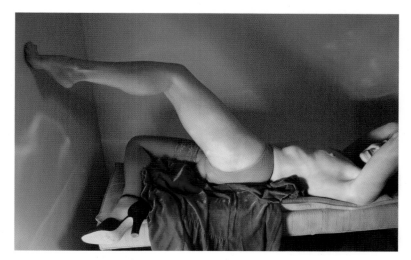

SCARLET, 2012

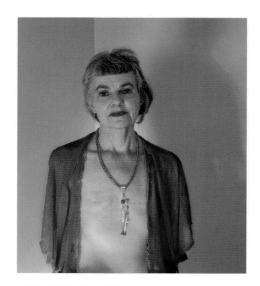

IMPERMANENCE, 2013

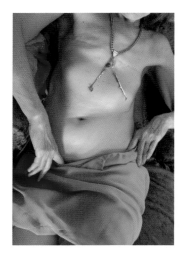

SWORD AND AX, 2013

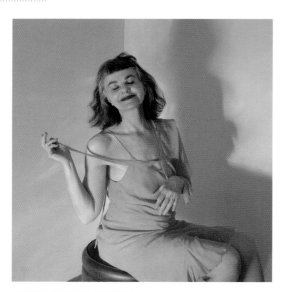

RADIANT GESTURE, 2013

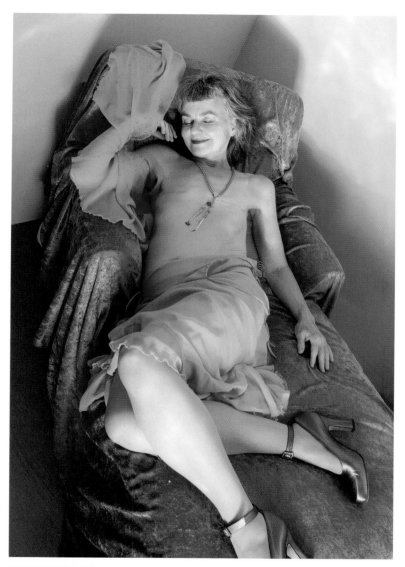

THE CHAISE, 2013

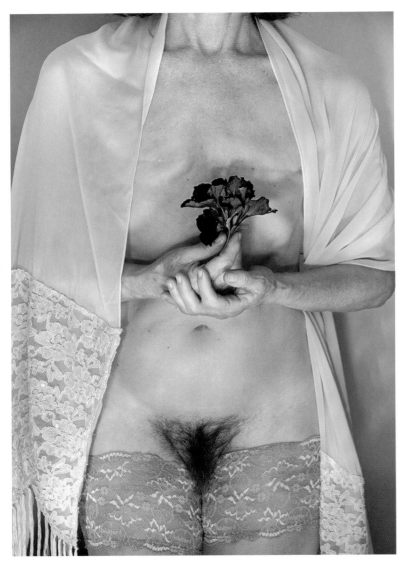

PANSIES, 2013

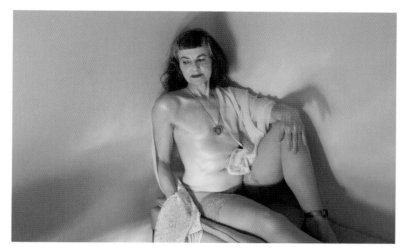

A RENAISSANCE, 2013

THE ETIQUETTE OF BOOKS, 2015

CLARITY OF SHAPES, 2015

THE SCHOLAR IN CHIFFON, 2015

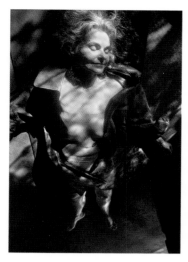

SAVASANA, 2016

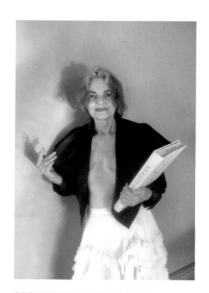

SPEAKING OF BEAUTY, 2016

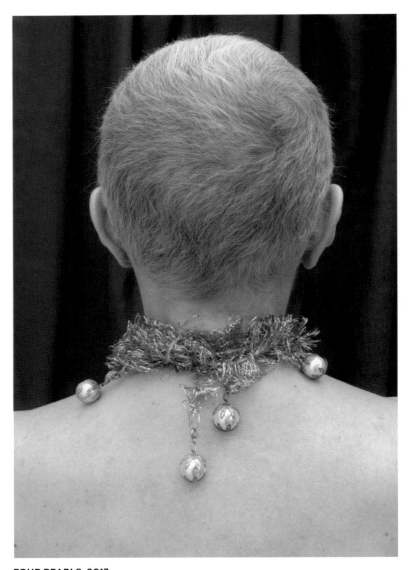

FOUR PEARLS, 2017

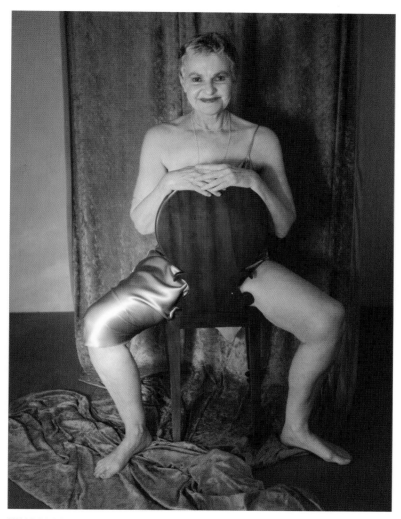

UNAPOLOGETIC BEAUTY I, 2018

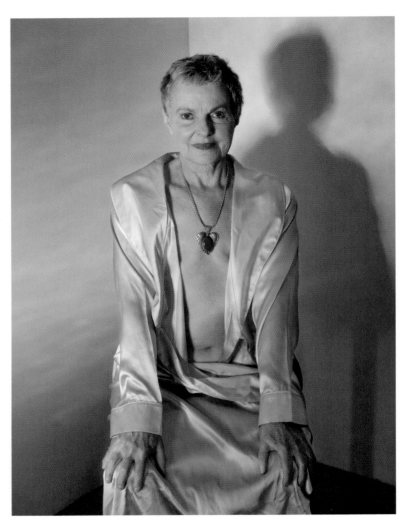

BEAUTY REDEFINED, 2018

The radical physical change required adjustment. My torso startled me for a while when I gazed in the mirror. In profile, the difference from before was most pronounced, because my rib cage is prominent and it now stands out much farther than my supremely flat chest. Funny—a man with whom I had a most succinct affair in 2010, when I was sixty-two, said that my rib cage aroused him the most of any part of my body. Maybe he'd love the new look!

I soon admired my new shape naked or dressed. And because one must realign her posture without what once was probably the prow of her ship, I reminded myself frequently to stand tall, drop my shoulders, and lift my chest.

I wasn't worried that my lover's lust for me would disappear or even wane. She had seen my body within hours of surgery, and she and my sister helped me learn how to empty the drains, tubes to remove fluids, that the surgeon had positioned a little below the outer edges of the incisions. My lover saw the black bruising on the right side from my armpit to hip, which I assured her and my sister didn't feel anything like it looked. My squeamishness about dealing with the drains, in which you see reddish liquid from your own body turning lighter as you heal, was comparable to my scared anticipation of seeing the incisions for the first time, after the Steri-Strips covering them peeled off. What I saw calmed me, and emptying the drains became an easy task within a day, although a tinge of eeriness clung to feeling their warmth from substances that usually remain a mystery to the senses.

I did not ask my lover if she loved my beauty marks, because I knew that she loved *me,* and our initial tentativeness, which stemmed from the discords, oversensitivities, and vulnerabilities that surrounded the breast cancer crisis, vanished as our love and attraction, a cellular bond, proved more potent. When her fingertips tenderly followed the beauty marks, as did her lips and tongue with delicacy and passion, they unwound me from the tensions of fear.

AT THE BEGINNING OF OUR FIRST VISIT, a new friend, older than I, very astute, political, and direct, was looking at my chest now and then. I may have told her about the bilateral mastectomy before or after she mentioned that she disliked her low breasts, what was happening to her body with age. That matter-of-fact observation preceded a similarly plain statement about my appearance: "It's a good look."

Apology

APOLOGY: (1) speaking in defense; (2) used to cover embarrassment; (3) a cultural environment endured by girls and women.

When women and girls apologize for their perceived beauty problems, they put forward a peculiar defense. Showing that they are aware of their lacking status by spelling out a flaw, failure, shortcoming, offense, or a dereliction of duty as a female shields girls and women against the attack of hyperbeauty, which is anywhere that you can find ads, celebrities, fashion news, beauty tips, dermatology and plastic surgery Websites, Internet forums and communities, and simply face-to-face talk among females. The battlefield is everywhere, and apologies are a sad armor, because self-denial and apologies are close kin.

Apologies cover one's embarrassment (a forehead line, a stomach that curves, hair color associated with old age) about signs of life as it naturally occurs.

A cultural environment of apology can motivate actions that are unnecessary for physical well-being, such as dieting for hyperthinness, lifting breasts to an eccentric pertness, Botoxing teenage girls and women in their twenties, and dyeing snowy hair.[1]

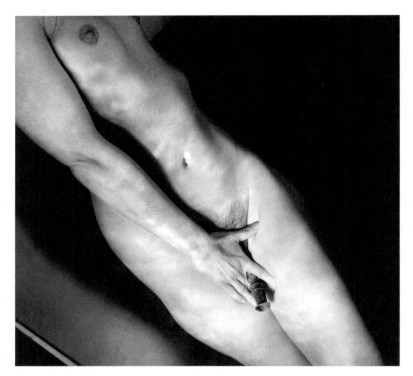

SPOUT, 1987

Types of apology interweave: self-criticism, undermining and demeaning oneself, and lamentation. Foils are another kind of apology.

Example of self-criticism: in *fat talk,* someone shares her self-disparaging internal monologue. That promotes commiseration, a bonding based in apology.

Example of undermining oneself: a friend compliments your hair, and you say, "Oh, I didn't wash it today," or "My roots are showing," or "It'll look better when I get a haircut next week." No, you're telling her, I will not accept your compliment, when you could have simply said, "Thank you," rather than indicating that no, you're really not up to par.

Example of demeaning oneself: I introduced myself to a new patient in her twenties in a chemotherapy infusion center where I volunteered. Her nose was magnificent, like the noses of gods in Mayan sculpture: long, big, and distinctively shaped. I said, "Your nose is beautiful." She touched it and responded, "I hate my nose."

Example of lamentation: "I'm a faded flower," bemoaned a close friend. We're the same age and became best friends when we were eleven. After hearing her plaint several years running, from around 2011 into 2014, I laughingly and lovingly put my hands around her neck and teased, "If I hear you say that one more time, I'm going to strangle you!" She laughed too. She looked tired, not faded. Misdescriptions can become firmly held beliefs that mold one's appearance to fit them.

Definition and two examples of a foil: this form of apology starts out feeling affirmative and encouraging, even inspiring. A person, enter-tainment, or advertisement gives girls and women reason to feel good about themselves, but the same old, same old undercuts affirmation. A foil apology can be subtle and difficult to detect, especially because one's tears in response to poignancy, or laughter in response to playful-ness, may interfere with clear perception. Affirmation is itself the foil for the apology. Sometimes research and analysis are necessary to dis-cern a foil apology.

Example 1 of a foil. Corporate and brand campaigns in the name of body positivity are often foil apologies. Brands and companies that direct their sales at women have an obvious agenda: drumming up business. Such campaigns cover up that motive by manipulating potential buyers to feel good. Dove's first entry into the body positivity arena, Real Women in the Spotlight, appeared in print ads and on billboards in 2004. It began Dove's Campaign for Real Beauty, which continues into the present. Women size 4 to 12, according to Dove, and of varying skin colors pose in white bras and panties. No one is butch. No one is a celebrity. All are young. And they have smooth, taut body skin. No wonder! They are advertising Dove's new line of body-firming products, and the images were retouched. The wizard of retouching fashion and celebrity photographs, Pascal Dangin, exercised his magic, falsifying the women's real appearance. "Do you know how much retouching was on that?" he asks in a 2008 *New Yorker* profile. "But it was great to do, a challenge, to keep everyone's skin and faces showing the mileage but not looking unattractive," he says. Pathetic—young women are perceived as already showing wear and tear. I recommend that you read the Dangin profile to understand the monstrously huge fakeness of hyperbeauty. He knows that his skills give unfair advantage to celebrities by perpetuating beauty unreality, but he is a pragmatist: "I'm giving the supply to the demand." A revolution in beauty does not come from lies. Nor does it come from the paradox of challenging hyperbeauty and selling big chunks of it at the same time.[2]

Example 2 of a foil. A video by a noncelebrity female singer-songwriter went viral in 2014. She was fifty-five at the time and performs with a cohort of peers whose girlie good time is sunny and humorous. We hear repeatedly, "Older ladies are divine" and other phrases of self-embrace. Older women watching the video could easily laugh in happy self-recognition. Yet a litany of features that a cosmetic surgeon might want to fix fills the verses: "Eyes baggin'" and "skin saggin'"; cellulite, jiggly flesh, a poochy stomach, double chins; "saggy breasts that drip from my

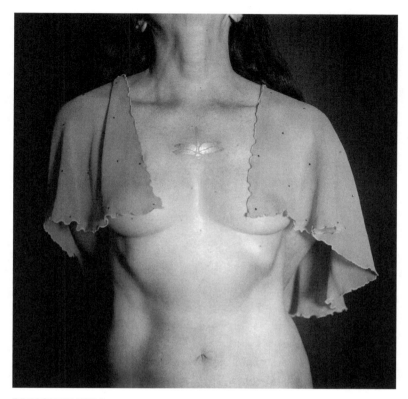

DRAGONFLY, 2004

chest."[3] Realism, you say—but we are hearing descriptions of the older female body that are highly charged with negativity. They are a litany of loss, and they are conventions about that body being ugly, so they are a language of apology. Reality is not just "out there" already described. Human beings name it. Which means that they can change the language.

THE MORE THAT GIRLS AND WOMEN assess one after another detail of their appearance as inadequate, the more they can apologize for. Apology means progress in the hyperbeauty market, which creates ever more products and procedures to fix deficiencies that the market itself dreams up. In terms of a bedazzling—or bewildering—number of choices for the equally befuddling myriad of beauty wrongs, Clarins, an international skin care and makeup line, is a winner, with thirty-one products in its "Anti-Aging" category, when I searched early in 2015. (A few were repeats in two sizes.)

Another outstanding example of market excess is cosmetic dermatology, which offers a mind-boggling number of services. DermaNetwork, "your premier online resource for skin rejuvenation," listed twenty-one injectables and fillers, twelve fractional resurfacing lasers, and ten treatments specifically opposing age, when I searched the menu.[4] The hyperbeauty market epitomizes Western civilization's economic model of unlimited growth and overproduction. Perhaps a Clarins "anti-aging"[5] item works well for someone, but she certainly cannot *need* every one. Deciding on basic necessities, such as cleansing and hydrating or moisturizing for skin care, can be frustrating and unbalancing when more (for sale) is truly too much.

I AM NO PARAGON of an untouched face and body, but I have never been big on apologizing for my appearance: calling myself fat, maligning my age, looking for problems where none exists. I have done nothing wrong by reveling in chocolate cake, having oily skin, and going as is in

clingy tops after a bilateral mastectomy. I see lines at the outer corners of my eyes and spider veins on my legs.

No apology needed.

I could apologize for my so-called frizzy hair, but as far as I'm concerned, "frizzy" is a marketing ploy to sell special smoothing products. I love my wavy hair with its fluffiness that is lots or little depending on if I brush it, which increases fuzziness; humidity, which can make my hair really big; and the shampoo and conditioner that I use. Something that is anathema to the beauty ideal may actually elicit compliments, such as my words to the girl with the Mayan nose. Likewise, an incident with the "frizz." "My hair is so big," I noted to a friend as we were looking in a mirror on a Tucson monsoon day. "It's called volume," she quipped. "I'd like some!"

No apology needed.

I have had nonablative laser treatments, microdermabrasion, and glycolic peels. I tend to be irregular about them all. I have colored my hair, but not since 2010, and I directed colorists to leave in some white and silver, because they looked beautiful to me and I wanted a reasonably natural look. I could say that I have acted in apology for my facial lines and creases, large pores, and elderly hair color. I lean toward exercise, healthful food, rest, meditation, and a happy life for the care of my appearance, and maybe my skin texture has improved as much from those as it has from nonsurgical cosmetic procedures.

No apology needed.

Hyperbeauty

HYPERBEAUTY IS SLICK, rigid, and generic. It is the flash of flesh appeal. It is today's beauty ideal. Hyperthin, hyperfeminine, hyperbosomy, hyper-sexy, and hyperyoung are the privileged quintet that stokes the standard.

Hyper: excessive, frantic, feverish. Women and girls can pursue beauty at a breathless pace, even if they are skeptical of media and market hype. Our minds are wallpapered with foreign images and infused with alien soundscapes. In a world awash with advertising that demands visual and aural attention, accosting us in the pseudoprivacy of home on our televisions and the tablets and smartphones that we choose to accompany us everywhere, assaulting us in public spaces while we walk to work in a big city, catch a plane, or work out in a gym, hyperbeauty's commercial snares block, derail, and obfuscate words and pictures that surface when one is allowed her own dreams, and false pleasures seep into a person's consciousness. The more that commerce blankets our everyday and interior worlds, the more we become receptive envi-ronments for it. Our passivity can be paradoxically passionate as we consume hyperbeauty, the doubts that it implants in us, and the remedies touted by the marketplace for our beauty ills.

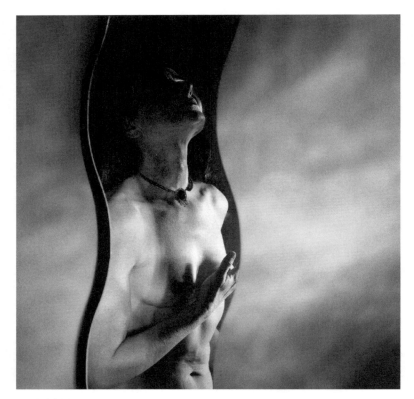

DIVA, 2006

Hyperbeauty threatens pleasure because it afflicts one's sense of reality. Is a size A cup okay? Do I look like a hippo? Do my wrinkles make me a hag? Will eating those cookies start a downward spiral to fat? Will I feel sexier at the party if I buy the designer heels?

Hyperbeauty builds a market for doubt. It demotes girls and women to self-perceptions of *hypo*beauty. Believing in one's hypobeauty is not a natural-born female trait. The imperial reach of media and the marketplace trains girls and women in self-scrutiny and self-surveillance, so that they want to buy fashions, products, and medical and spa treatments that will remove doubt. But the hyperbeauty bazaar—global, 24/7, overstocked—works to enhance doubt by designing an insatiable consumer. The system multiplies wants by extolling newness—the latest style, the most innovative procedure, a state-of-the-art surgery, a scientifically advanced facial serum formulation—and by clamoring about celebrities, whose remarks and images sell products and who sometimes become purveyors by developing a fragrance or clothing line. Be on the cutting edge and you will be a cut above your competitors, who are your self-doubting peers. Emulate a celebrity, and her appearance, fame, and wealth will rub off on you, because you merge with her identity.

The sell of the glutted super-emporium penetrates girls' and women's hearts, which sink, because the message of the glut is this: the more there is, the more you need it. One face cream is not enough to cure your facial maladies. You've got acne and large pores. You've got wrinkles and redness. You've got dry skin, oily skin. No matter what your skin, it is never beautiful enough. None of you is. You've got cellulite, rough elbows and heels, and overgrown cuticles. You've got breast and buttocks sag and hair that needs to be blonde, not your natural brown or silver. You've got a moustache. Your pubic hair creeps up your belly, and you probably shouldn't have any at all. You've got spider veins on your face and legs. You've got brown spots there too. Your nose is too big, and so are your thighs. If you live in a female body, you are a profusion of beauty problems.

Glut makes gluttons, and it pushes their sunken hearts deeper into the abyss of doubt.

Our doubt is not our own. We are full of *somebody else's* doubt, the somebody else being Big Beauty, an industry that can only expand by putting a price on beauty.

BUDDHAS AND BODHISATTVAS WEEP. Deities in charge of strife, whose random laughter at human battles momentarily shrinks the hearts of animals and the buds of flowers, observe in amazement tactics and consequences of war on the females of an entire planet. Divinities of flesh, bone, and muscle, of blood and beauty beat their bejeweled fists against the grounds of heaven. Because they all see into a vast and growing pool that submerges girls and women in distortions.

Selected Facts from a Pool of Distortions

A former Argentine beauty pageant winner dies of complications after plastic surgery meant to firm her buttocks.[1]

Fat talk, the negative assessment of one's own body size and appearance, is common in face-to-face conversations of adolescent girls whose weight and height are average.

Adult day spas offer services for girls four to fourteen, with separate menus for them.[2]

Occurrences of anorexia and bulimia are increasing.

Top surgical procedures for women are breast augmentation and liposuction.

Women undergo the following procedures, sometimes all of them, in order to look like a celebrity: breast augmentation; buttocks lifts; liposuction to chin, hips, and thighs; rhinoplasty; and fat grafts to cheeks.[3]

Envy in aggressive green highlights an online article about liposuction doctors who make a woman's wish to resemble a star come true. That green

word headlines a black-and-white photo of a woman's eye with heavily mascaraed lashes and an eyeball, fiercely staring, in the same green.[4]

A fashion magazine for teens runs an article that features an eye cream to prevent aging.[5]

Signs of age must be eradicated. Fashion magazines and catalogs use *erase* and *target* to urge women to remove lines from their faces and years from their appearance.

Six-to-eight-year-old girls commonly indicate that they are bigger than their body ideal.

Scores of Chinese women visit South Korea for body modifications, from double eyelid surgery to facial restructuring.[6]

The print magazine for four- to twelve-year-old fans of a construction toy brand tells girls to know their face shape so that they can get the best haircut for it. Oval is the most desirable because any hairstyle suits it.[7] Hairstyles for face shape—round, oblong, triangle, diamond, square, heart, oval—are conventions in mid–twentieth-century beauty etiquette manuals. Today, celebrity face shapes are a popular online subject.

Female characters in popular films are more than twice as likely as male characters to be thin, partially or completely naked, and wearing sexually revealing clothes.[8]

Reduction of wrinkles on the face and neck with various brands of Botulinum toxin—Botox is the best known—is stupendously popular.

In cyberspace, girls and women can "thinspire" themselves with forums and communities that are pro–eating disorders.

The motto of the American Society for Aesthetic Plastic Surgery is **we are aesthetics.**

Selected Observations about a Pool of Distortions

Ads for feminine wipes use the term *down there,* suggesting that female genitalia are bargain basement items. *Vulva* remains a publicly forbidden

word. And *feminine wipes*? It is laughably mealy-mouthed and insinuates that anyone with a vulva wants to be feminine and that female genitalia need exceptionally singular cleaning, presumably because they're *so* nasty smelling. Not to mention nasty looking. Disgusting to the senses and therefore aesthetically repulsive. (Dude Wipes are available, without the taint of foulness.)[9] Want to correct that bargain basement body part? It can be prettier and smaller with a non–bargain basement priced labiaplasty—$3,000-$9,000.[10] Scent removal not yet surgically available.

As ever, I am devoted to vaginal aesthetics, redressing the vagina's culturally inherited ugliness. The vagina's beauty is rich and sweet—smell, taste, and touch. How I love this haunt of mine.

A fashion magazine sends out a brazen consumerist call: **See it. Want it. Buy it**.[11] Imperative. Be impulsive. Bold type, bold you.

A young woman on the University of Arizona campus in 2014 wears a T-shirt emblazoned with **Born to be famous.** She may not be a candidate for the liposuction and cosmetic surgery that fulfills her possible desire to look like a celebrity, but I doubt that she wore the slogan in complete irony. **Born to be famous** is a fantasy of the perfection that people imagine is the life of celebrities: hyperbeauty, huge wealth, dreamy mate, luxurious homes, and haute couture.

At a restaurant that I frequent, two women dining by themselves said, "Yes," to the dessert menu. Asked by the server for their decision, here's the choice: "We decided we can't have any." Not *don't* want any but *can't*. It is unlikely that they didn't want dessert when they took the dessert menu, but the idea of "sinful" sweets—you're bound for beauty hell if you partake—preys on women and girls. We all know that a dessert now and then isn't going to hurt you. (Who knows? Maybe they eat sugary treats all the time and just *couldn't* do it that day, but I think that's unlikely.)

A young woman in the chemotherapy infusion center where I volunteered exclaimed that she hated her nose when I complimented her on its beauty. Her hatred of that big and distinctive feature that resembled

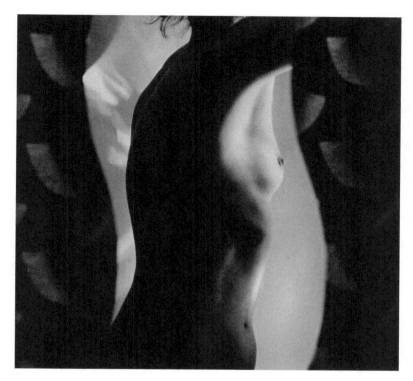

CRESCENTS, 2006

noses in Mayan sculpture may seem like a personal problem, and it certainly is. But hyperbeauty does not honor noses that depart from its bias toward a small, unobtrusive, white nose (Barbra Streisand's nose notwithstanding). So a nose that looks Mayan, Jewish, or African American may cause consternation in a woman who was born with it. The Website of the Aesthetic Institute of New York and New Jersey, run by a board-certified facial plastic surgeon whose specialty is rhinoplasty, instructs us: "African American and Ethnic noses present several anatomical differences when compared to the Caucasian nose. These variations create a much higher degree of difficulty for the Rhinoplasty Surgeon operating on them. . . . Wide nostrils can sometimes create or contribute to the appearance of an oversized nose that doesn't fit the face."[12] Huh? A racial rationale of beauty judges the appropriate size of a nose and its rightness for a face.

HYPERBEAUTY FANS THE FLAMES of envy. It stokes competitiveness and self-absorption. If you see someone's wrinkles before much of anything else, or first thing compare her weight to yours, or assess the size of her breasts or buttocks, then you are not seeing the whole person created by character. You are not even seeing her complete external factuality. Seeing incompletely is the training we receive from hyperbeauty. It impairs vision.

The worldwide body positive movement is an uprising against hyperbeauty. It is simultaneously encouragement and quicksand.

Boisterious and often poignant, the movement's primarily female proponents redefine beauty with mostly visual imagery as affirmations intended to show women and girls that they are beautiful as they are. Entertainers and product brands also charge into the arena using the movement's implicit motto, "Be yourself." That slogan makes women and girls into winners by putting their beauty into their own hands rather than the clutches of the hyperbeauty sell. Tips for feeling and looking

good accompany the visuals, as can diary-like introspections, songs, and voiceovers.

If these insurgent projects, which can be blazingly popular, were as ubiquitous as the conventions of hyperbeauty, women and girls might feel as good about their appearance as they now feel bad about it. I say "might," because the quicksand of apology, which is commerce, and the quick fix too often interfere with the encouragement and inspiration that can lead to an individual's essentially changed heart about her looks.

Example 1 of encouragement and quicksand. Love Your Lines, begun on Instagram in 2014 by two mothers who wish to remain anonymous, features followers' black-and-white photos of their stretch marks, often from pregnancy, with short, pointed writings by them about those affronts to hyperbeauty.[13] The format is straightforward and lends itself to no-nonsense pictures and text. Apologies abound, but so does redemption from them.

Example 2 of encouragement and quicksand. Tess Holliday's Eff Your Beauty Standards, started on Instagram in 2013, is filled with photos of fat women and texts that seek to spark loving self-acceptance of fatness.[14] She is a plus-size model who wears a size 22. Her Website, when I accessed it in February 2015, featured photos of Holliday (then with the surname Munster) and plenty of particulars about her, including an FAQ page on which she answered chiefly questions about externals, such as clothing and makeup. She wore *lots* of makeup, so much that it usually hid her natural beauty in the glittering array of images on her Portfolio page.[15]

Like Love Your Lines, Eff Your Beauty Standards provides a place for followers to unburden themselves and to assert and build their confidence. However, unlike Love Your Lines, which neither sells nor advertises anyone or anything, an earlier version of Holliday's Website promoted Holliday along with goods and services. That list included her clothing line, a hair salon and brow specialist that she used, and

her favorites in skin care, makeup, shapewear, jeans, bras, corsets, and places to shop. Information from a fashion expert about where to find good plus-size clothing is undeniably valuable, yet the commercial angle threatened to overwhelm the content that fat is beautiful.

Example 3 of encouragement and quicksand. For her *Before & After* project, which began in 2014 at *BuzzFeed* and went viral that June, the young journalist Esther Honig contracted almost forty people from more than twenty-five countries to Photoshop her bust-length portrait with the request to "make me beautiful." The results show wildly differing Honigs, which proves, in her words, that "Photoshop allows us to achieve our unobtainable standards of beauty, but when we compare those standards on a global scale, achieving the ideal remains all the more elusive."[16] Her venture is artfully simple in its presentation and thoughtful, but a problem without any tools for solving them becomes a reiteration of the slipperiness, if not impossibility, of attaining a beauty ideal.

Example 4 of encouragement and quicksand. On March 30, 2014, the then-seventeen-year-old singer Lorde tweeted about her acne. She commented on two shared photos: "i find this curious—two photos from today, one edited so my skin is perfect and one real. remember flaws are ok:-)." Great remark, but hearing that flaws are fine, even from a celebrity, is probably not enough to release someone from negative feelings about her appearance.

Example 5 of encouragement and quicksand. Grammy Award winner John Legend's video for his song "You & I (Nobody in the World)" moved me to tears the first time I watched it. With lyrics telling a loved one that she is "beautiful as you are" and "You don't have to try. Don't try," we see females from an infant to an elder with one reconstructed and one unreconstructed breast, presumably after breast cancer surgery, and we see different races, a transgender individual, butch and feminine looks, a pregnant woman, a fat woman, a girl with Down Syndrome, and another older woman who removes a wig to show her hair loss (due to

chemotherapy, I assume). We see them all sad and dissatisfied as they appear to gaze at their reflections. Later we see laughter and pleased or thoughtful self-assessments. Love is the current that flows throughout the video—love within lesbian and heterosexual couples, love between mothers and children, and the clear point that love of oneself is the key to contentment. All in less than four and a half minutes. Legend's singing is full of passionate tenderness. And yet his beloved in the video performs the beauty ideal: she is the model Chrissy Teigen, who is Legend's wife. Dejection about appearance is resolved in a veritable instant, and the commercial slickness of the video sentimentalizes the message, downgrading its honesty.

THE PUBLIC FACES OF MODELS and beauty-icon celebrities result from smoke and mirrors. An entertainment and celebrity magazine's online look at famous women without makeup is sufficient evidence that their beauty is an illusion: they wear a mask. Paired photos of celebrities, none old, taken generally within a year of each other, show every woman at an event—heavily made up and primed for an appearance, and in everyday life.[17] Only a few of the latter pictures show someone looking "ugly," as if the photographer deliberately wanted to slight them. The without-makeup pictures show the true character of an individual, which develops throughout her life. That realness vanishes in the drastic stylization that is the public allure of hyperbeauty.

Beauty icons tend to remove women and girls from themselves in a way that psychologically disadvantages them. Marketers and the media lead us to believe that we are at a physical disadvantage, but they capture, and may imprison, someone's mind and heart in order to do that.

Precisely because we do not know beauty icons, they are unparalleled, digitized foci for commercial fantasies that feed the psychological and emotional insecurities of women and girls. In the whirl of fantasy we believe, enough to buy a product or service or surgery, that by modeling

ourselves after this or that celebrity we will look similarly attractive. Insecurities—poof! I would not say that security in one's appearance comes only from someone's thoughts and feelings about herself—actions are absolutely pertinent—but familiarity with one's soul-and-mind-inseparable-from-body goes a long way in producing the confidence to be oneself rather than to imitate a celebrity brand.

THE BODY IS AN INCOMPREHENSIBLE MYSTERY, like nature, to which it belongs. The consumerist enterprise tricks us into believing that the mystery can be solved, that the many little crimes against and by the body, such as broken capillaries, striae (usually called stretch marks) left from pregnancy, dark skin under the eyes, and flat buttocks, which, according to the hyperbeauty bazaar, all kill the body's beauty. We hire personal trainers, dermatologists, and cosmetic surgeons to sleuth for us, but the body is not a solvable mystery, like a crime in a detective novel.

We are stars, not crimes—offenses or outrages against beauty. Physics informs us that human beings are actually stardust,[18] and the musician Joni Mitchell reminds us, in her song "Woodstock," which she first performed in 1969, of the same fact. That reality, she suggests, means that we belong in the Garden of Eden, an earthly paradise. In that garden, beauty blooms. Its seed is cosmic plenty.

BEAUTY *Heroes*

Beauty Heroes When I Was Young

My mother was a beauty. She kept her creamy skin and black hair well into maturity. I'm sure that my love of red lipstick, which I have often chosen for myself, came from her signature scarlet, from which she never deviated. Mom clothed her slenderness in tailored simplicity, and her cap cut framed an intelligent face that Dad called heart-shaped. Femininity radiated from her delicate, expressive hand gestures and graceful ease of stance and walk, and her freshness stayed with her throughout her life.

The beauty of a fat receptionist in the hair salon at Henri Bendel, the specialty luxury store in New York City, so struck me that I found it difficult not to keep staring at her. I was in my early twenties.

Santa, born in Italy, was our housekeeper for several years beginning when I was around seven. Her strong features, olive skin, black hair always arranged in a bun, moustache, and robust body exuded physical and emotional power. Her looks were as fearless as she felt to me. Mom described Santa as "handsome." I remember her wearing an elegant sheath to a Christmas party that my parents gave—party flair under an apron. Santa is an everlasting acme of imposing style.

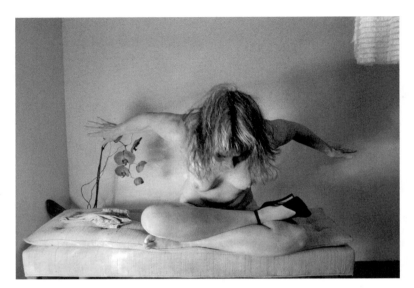

KABUKI, 2012

Jenny was a friend of my grandparents, and after Gramps died, and family and friends were sitting shivah with Gram presiding, Jenny and I talked a bit. She must have been in her seventies or older, I in my midtwenties, and her beauty and the vigor that engendered it captivated me. I didn't want to take my eyes off her. The absolute details of our encounter have faded, but I complimented Jenny on her beauty and asked how she maintained it. The gist of her response stays with me: you care for yourself every day; your health and beauty are a continual labor of love.

Beauty Heroes Today

Sometimes I think my sister and I look almost like twins with our broad faces, high cheekbones, large features, full, wide mouths, and dark hair. (Mine has silvered a lot and hers is still mostly black, naturally.) She is eleven months older than I, and we are comfortable in our contrasting styles, hers with work or cowboy boots, a flannel shirt or ample T-shirt, jeans, and short hair, mine with skirts in various lengths and styles, clingy or flowy tops, richly colored lipstick, and long hair. Her sturdy body conveys a steadfast heart and mind, and she shares the sweet intelligence of face with our mother.

Tall and lean with big red hair, my Kat is immensely alluring in menswear, such as a long-sleeved shirt under an Armani jacket, trousers belted in leather with a buckle of coral and silver, snakeskin boots, and a gold ring set with a very large and arresting rectangular amethyst. Kat and I are married, and I have never seen anyone's face transform into as many expressions as Kat's does, and in its transformative pliancy I see the enchanting spontaneity of a child in the face of a person in her sixties.

Ariana was a student in many of my classes at the University of Nevada, Reno. She was in her early twenties when our friendship began in 2001. Her open face speaks of curiosity about life. Whether she wears bangs or not, whether her blonde hair is below or above her shoulders,

whether she is feeling more or less svelte, Ariana's clear spirit radiates beyond any details of her appearance. Spirit—it drew us into a friendship in which playfulness about beauty is part of the spiritual journey that early on we knew we were sharing.

Glow and sparkle inhabit the heart of Frances's femininity. I think of diamonds, pearls, and aquamarines, charges of color and energy that so suit her. Even her voice glimmers—its bright tone and the lilt that it still carries from her native Ireland, which she left at age eighteen. Her cropped hair is a dream of silver-white. All of these colors, gleams, and twinkles plus moonstones in delicately precise silver settings, clothing in magenta, gray, and lavender, and an occasional zing of brilliant red, belong to the light and power that Frances generates.

None of my beauty heroes is a celebrity. Celebrities have never looked more beautiful to me than the general population.

In my college years I spent a lot of time in New York, where I witnessed fashion shoots on the streets. My response to the models, who seemed to be around my age, was, "They don't look any better than I do." That perception did not come from ego but, rather, as an honest observation of reality from a young woman who loved empirically studying the visual world, was becoming an art critic, skilled at looking closely and analyti-cally, and, not least, enjoyed her own appearance.

The model Penelope Tree attended the same college that I did, and I'd see her in the cafeteria. She was famous at the time, tall and thin and no more beautiful than the rest of us students, who were mostly women. (Sarah Lawrence College began admitting men during my years there, but we women overwhelmingly outnumbered the males.) Her broken-out complexion surprised me one day, but why? Like all of us, she lived in skin, and like some of her peers, me included, she couldn't count on the smoothness of her complexion.

Helpful beauty heroes are people whom we know in everyday life. Not because we can observe their "flaws" but, rather, because we *feel*

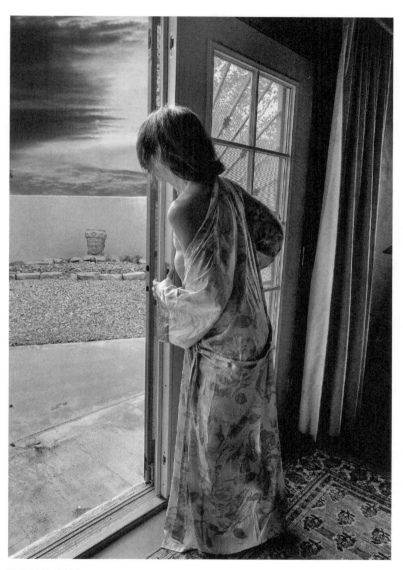

BUDDHA, 2014

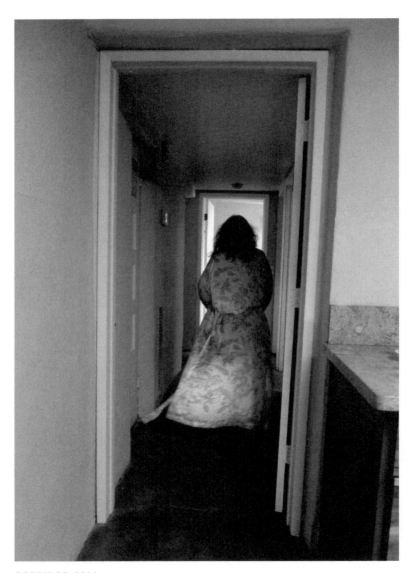

CORRIDOR, 2014

as well as see their beauty. We witness the results of their reaching into themselves and perceive their soul-and-mind-inseparable-from-body. That is not the case with beauty icons. Everyone is a mystery, including the people we know best, but beauty icons are massively unknown to us and therefore not useful. No matter how often we enjoy them on one screen or another, read about their scandals, ooh and ah at their red-carpet style, or watch interviews with them, most of us have no idea how a beauty icon truly feels and thinks about her appearance or how she amends it.

BEAUTY *Redefined*

A GOOD THING TO REMEMBER is that beauty ideals are transient and historically particular. An ancient Greek exemplar of beauty, the Aphrodite of Knidos, a sculpture by Praxiteles dated 360 to 330 B.C., represents the goddess of beauty and love with breasts that are way too small and flesh that is way too much for today's beauty ideal. The Renaissance master Titian painted several Venuses in the mid-1500s; most of them are even plumper than the Aphrodite of Knidos, and their breasts are modestly sized like hers. The female nudes of Rubens, a titan of Baroque art, are fat in comparison to the current paradigm. Their ampleness looks lush and squeezable. Manet's *Olympia* (1863), scandalous in its time for depicting a prostitute frankly displaying her wares, features a rare bird in the history of Western art—a thin figure compared to other nudes of her period.

In the world of actual people, Marilyn Monroe, an Aphrodite of her time, wore a 36D bra, and her weight varied between 118 and 140 pounds.[1] Her waist was tiny, her figure hourglass. The famous mid-1960s model Twiggy, born Lesley Hornby, was scrawny and flat-chested. Turning from bodies to faces, Mursi tribeswomen, living in Ethiopia, wear lip plates

for beauty enhancement. A conspicuous unibrow is a renowned feature in self-portraits by the popular and prolific Mexican painter Frida Kahlo (1907–1954), known for her flamboyant beauty as much as for her art.

None of these examples fits the hyperbeauty mold, and each helps to prove that the truth of women's beauty is in its diversity and changeability.

IN *SIX NAMES OF BEAUTY*, the philosophy professor Crispin Sartwell's examination of various cultures' words for beauty and his ideas about it, he defines the English word *beauty* as "the object of longing," and he associates beauty with loss.[2] When I taught his book in my class Beauty and the Body, I did not hide my displeasure with that association. Let us court different words for beauty: the Hebrew *yapha,* which Sartwell defines as "glow, bloom," and the Navajo *hozho,* which he defines as "health, harmony."[3] Courtship is pursuit, an active seeking that is an invitation to the object of one's desire. Glow, bloom, health, and harmony: inviting them into our lives attracts them to us.

***WABI-SABI* IS A JAPANESE AESTHETIC** that values change and the signs of it. It is a worldview.[4] I am not aware of anyone applying that aesthetic to personal beauty, but wabi-sabi is a powerful way to cleanse the palate and clear the air of hyperbeauty:

Wabi-sabi	Hyperbeauty
fresh perception through an observer's discernment	stale perception through a consumerist and celebrity-obsessed lens
idiosyncratic	generic
subtlety	overstatement
real	artificial
flawed	perfect
appreciation of nature and its effects	debasement of nature and its effects

autumn leaves underfoot	golf course
visible wear, use, life lived	eradicated wear, use, life lived
age is a virtue	youth and its affectations are privileged
richness	poverty and craving
impermanence	changelessness
true character	fluff

A wabi-sabi perspective appreciatively regards cracks and broken or missing pieces of pottery. Sometimes the Japanese art of *kintsugi* "repairs" such features by drawing attention to them.[5] Kintsugi is akin to wabi-sabi, and the technique includes using lacquer dusted or mixed with powdered platinum, gold, or silver for attaching or filling in missing pieces or replacing them. Imagine creases and lines enhanced with a silver, gold, or platinum makeup, postmastectomy beauty marks similarly highlighted, flesh that has experienced trauma or undergone decades of age honored with the colors of precious metals. Those are transformationally amazing sights.

THE MOST BEAUTIFUL SIGHT is "whatever you love best," declares the ancient Greek poet Sappho.[6] Like her poems, her biography exists mostly in fragments. She may have been born between 630 and 612 B.C.E. and died around 570 B.C.E. "Whatever you love best" can be as various as the beauty in eyes of beholders, but it pinpoints love as the filter through which a beholder sees. The sight, the object, is perceived with love. Its impact is emotional and spiritual more than visual.

PEOPLE ARE BORN with a unique character, and we shape that character as we live. Thereby we shape our beauty. Beauty results from true character, which is the seat of radiance.

A philosophical guidebook for samurai, written in the eighteenth century, can instruct us in true character. In *The Demon's Sermon on*

the Martial Arts, by the samurai Issai Chozanshi, the demon is a sage of swordsmanship, which means that he knows the secrets of life and can impart them. Through conversation, the demon enlightens a samurai about his (martial) art, which is not a matter of techniques or violence but, rather, of true character. The demon advises, "When you follow your own true character and are not a slave to your passions and desires, your spirit will not be troubled."[7] True character is the key to releasing oneself from fabricated passions and desires pushed by hyperbeauty. Then girls and women can be peaceful beauties, and they can be works of art.

Essence and true character are equivalents, and according to the demon, "Essence and function are of one origin, are not distinct, and have no interval in between them at all" (107). If an ultimate function of unapologetic beauty is freedom, then the unapologetic beauty herself manifests freedom.

Unapologetic beauties, like the most excellent martial artists, live as consciously as possible in soul-and-mind-inseparable-from-body, which means that they transit the secular and spiritual and dwell in both. As William Scott Wilson, the translator of *The Demon's Sermon,* writes in his introduction to the book, "The martial artist . . . must inhabit . . . [a] liminal world between the sacred and profane to truly grasp his art" (21). For an unapologetic beauty, whose art is herself, to be caught up primarily or solely in the material world of hyperbeauty and its jive is to believe, for instance, that the particular fetching beauty of youth, which extends into the twenties, should and can be sustained through a lifetime. The demon would call that stupid; he asserts, "Youthful vigor is only temporary and is not rooted" (151). Other kinds of vigor must become part of one's art, such as the vigor of ch'i, which is indispensable in the demon's curriculum. Ch'i can be translated as vital energy, at once sacred and profane, and it permeates all living things, stones and mountains as well as human beings and animals. If a woman ignores her ch'i, she does so at her peril: it can congeal. It can be weak, too strong,

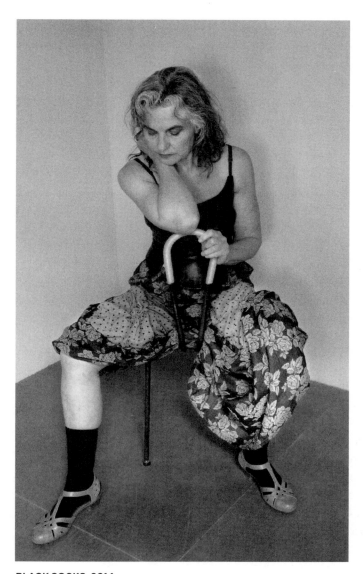

BLACK SOCKS, 2014

heavy, muddy, confused, or frozen. It can be dense and sluggish. One's ch'i can produce fearfulness, slowness, anxiety, or dryness. Ch'i can also be light and active and produce just-right action. In the demon's guidance, ch'i must be flowing and clear, and those qualities can be active in a person of any age. The practice of radiance enhances the clarity and flow of ch'i.

True character lies not in appearance per se but in the distinctive qualities and essential traits that physical appearance makes visible. True character lies deeper than personality, which is the mere surface of someone's being.

To lose one's true character is to lose one's true beauty. Cosmetic surgery can result in that loss. Major examples of that phenomenon are the entertainer Cher, known for her numerous face and body surgeries; Kim Novak, an actress whose appearance at the 2013 Academy Awards ceremony shocked viewers; and Renée Zellweger, the actress and producer whose "unveiling" of her new face at the 2014 *Elle* magazine Women in Hollywood Awards presentation caused a media brouhaha. Cher, born in 1946, and Novak, born in 1933, exhibit typical features of the mask that "defies" aging, such as unnaturally plump cheeks and overly arched eyebrows with *lots* of space between them and the eyes. Novak's face is stretched too tightly for her mouth to move normally.

Zellweger turned forty-five in 2014. Shockingly, she looked like an entirely different person. The changes: her eyes look larger and her brows are closer to them and straighter, her face is thinner, and she looks blandly pretty, which is the generic consequence of intensively effective cosmetic procedures. On the other hand, cosmetic surgery can also result in a subtle change that lifts a woman's spirit as much as it lifts her skin. One friend of mine had cosmetic surgery in her fifties and two friends chose it in their sixties, and afterward they looked exactly like themselves. In fact, had they not told me about their surgeries, I wouldn't have noticed a difference.

True character does not flaunt itself. If it did, a person would be suffering from the desire for fame. Nor does true character recede into a self-effacing humbleness. If it did, a person would be slinking into a sad passion for self-humiliation, through which she asserts her shortcomings and dulls herself by demanding that others testify to her defects, whether in oblique or blatant ways. In other words, she would apologize for being herself. True character does not remain ignorant of itself or its effects. True character is not self-congratulatory, but neither does it question itself to death nor exhaust itself with redundant self-doubt—should I? am I? what if I?—so troubling that it damns a person into retreat, most insidiously, from herself.

RADIANTLY UNAPOLOGETIC, Maiden Elder springs into action, ready to inspire women and girls to their own true character. She is like a goddess, larger than life, and like you and me, she is everygirl and everywoman.

Maiden Elder is without fixity of physical characteristics, age, or behavior, because she has everything to do with exceeding their culturally determined limitations on self-representation and self-creation, which are part of the self-discovery that unapologetic beauty invites.

Maiden Elder is like a samurai: she is a process, a continual event, and an unfolding; she is an artist whose self is her art because she is a master of true character.

Maiden Elder is a term of endearment.

Maiden Elder is a symbol of change. She is a queen of sea change— from hyperbeauty to your *own* beauty. And from youth to old age, an individual can move from maiden to elder and elder to maiden an unthinkable number of times with such subtlety that no distinction exists between the two.

Maiden Elder is neither here nor there yet everywhere. She is liminal—at the threshold of maiden and elder and across and beyond their borders. She can be cute and sharp-witted, playful and trusting, astute

and wide-eyed, sophisticated and girly, sexy and self-respecting, a leader and a learner. More than the best of both worlds, she is a new world.

Maiden Elder is wise beyond her years and silly as a goose. She is the wise fool, who questions what most take for granted and upends prevailing assumptions. Her irreverence comes from thinking with the heart. In thinking things through, people often think things to death. Maiden Elder thinks things to life, which means that she thinks creatively.

Maiden Elder is poised. Humility is poise, which is lightness. That lightness lives in a maiden's luster and an elder's surefootedness. It is the lustrous surefootedness and the surefooted lightness of Maiden Elder.

Maiden Elder is larger than the archetypes that she joins and transcends. Waxing life and opportunity overarch the Maiden, with her enthusiasm, virginal outlook and experience, and sense of enchantment, while the Crone evokes waning life and opportunity. She is darkness to the Maiden's dawn. In Western fine art, Crones are archetypal terrors, such as the ones rendered by the artist Francisco Goya in the early nineteenth century. Their grotesqueness is a far cry from the beauty of Maiden Elder. Immensely powerful, the Crone cuts the cord of life, an action that begins rebirth in the natural round of birth, life, and death. Maiden Elder cuts the cord of self-doubt, enabling rebirth in loving self-acceptance.

RADIANCE IS NONDISCRIMINATORY and it costs nothing. You can be radiant at any age, as any race or gender, whether you wear a size 26 or 0, shave your head, are bald from chemotherapy, or color your hair mauve. In other words, anyone can be radiant. That is because it is the truth of beauty.

Radiance emanates from happiness and love, which are pleasures, and the source of people's pleasurable experience of a radiant individual is the pleasure within herself. People say about someone who just fell in

love that she looks radiant, but the love that secures the most constant radiance is not romantic love but, rather, the love of oneself. It is a healthy self-love, not an arrogant, pretentious, or delusional imposition on others of look-at-me-I'm-so-gorgeous. A radiant person is her own true love, and the happiness that assures a more-than-intermittent radiant beauty is a foundational feeling of delight and contentedness in one's daily life.

Although we are habituated to a parade of beauty automatons and to praising synthetic glamour, we respond with instinctual pleasure to radiance, precisely because it feels true and it enfolds us in love that flows throughout us, soul-and-mind-inseparable-from-body.

Radiance is innately human, which means that we are all stars. We all have the capacity to shine, from the inside out.

THE PLEASURE OF *Pleasing Ourselves*

UNAPOLOGETIC BEAUTY THRIVES on pleasure. It is the result of pleasing ourselves. Pleasing *ourselves,* we are content. We enjoy the everyday pleasures of life, and that produces well-being and transmutes self-loathing. Pleasure matters. Not as some kind of simplistic fun or amusement and not as an escapist counterpoint to the world's abundant horrors but, rather, as a basis of loving self-acceptance, so that the dystopia of hypobeauty fades away.

People misunderstand pleasure. Misunderstanding arises from believing that pleasure is special—events and actions that stand out from the usual, ordinary, and daily. Rather than being at the center of living in general and therefore of one-after-another activity and experience every day, pleasure, people believe, is short-lived and a peak: it is party food rather than the staff of life.

Pleasure is the substance of living, so it is ecstasy and ease, making love and making dinner. In ecstasy and ease, a person can feel shifting balances of unforced appreciative engagement, simultaneous peace and stimulation, and those shifting balances are pleasure, one pleasure after another, so that pleasure itself becomes a foundation of existence.

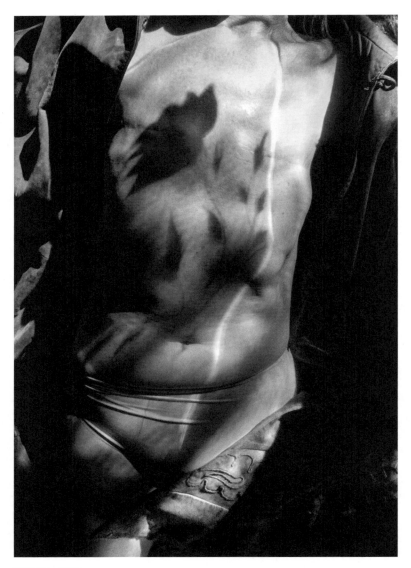

SCROLL, 2017

Attuned to those shifting balances, which means attuned to herself, a person loses the inclination to distinguish one or another pleasure being better or worse, for she perceives and experiences pleasures as simply and exquisitely differentiated from one another.

Religions tend to assess pleasure in a darker light, as do authors who critique consumerism. For them, pleasure is fleeting excitement, mere entertainment and self-absorbed diversion that come from craving, greed, and dissatisfaction. Pleasure has already led you into temptation, and it will never take you anywhere else.

As I define it, pleasure is not a temptress but, rather, a profound and beneficent guide that invites us to continually refresh our self-knowledge. Pleasure is part of the process of reaching into oneself, which is at the heart of unapologetic beauty, so it produces well-being through self-discovery.

That discovery is always a process, though people name their pleasures as things outside of themselves: it's the coconut cream pie, the Botticelli painting, the kiss, the century bike race, the sojourn in Paris, the favorite mystery writer's new book at bedtime, the leaf drifting from a tree, the butterfly that flew right their way, the generosity of friends or strangers. Naming pleasure as outside of ourselves is a convention.

Pleasure is a fluid way of living rather than a static state that is the perfect completion of an occasion or pursuit. Fluidity calls on a person to have faith. Faith is an act of imagination. To have faith is to enjoy infinite acts of imagination. This is the height of self-creation and therefore of creating personal beauty.

WHEN WE PLEASE OURSELVES, we are peacemakers, because pleasure is contentment that flowers from the satisfaction of knowing that we *have* enough and we *are* enough.

"What do we all want?" my beauty hero sister asked me a couple of years ago. She answered her own question with "Peace." How true!

I thought. When we are at peace, we are not seeking more—love, money, clothes, or digital devices. And we are not seeking better—vacations, cars, appliances, houses, or bodies, either our own or someone else's for sex.

People believe that their bodies are corrupted—the sweat and snot, the feces, and the surly plains and patches of hair growing from the smelly skin of both sexes—and that they become more so with age. The believer in bodily corruption is an addict, and the addict turns her past of perceived incremental corruption into a future of corruption full-on. No peace in the present. Believing in one's corrupted body, the present is an abstraction rather than an experience. A falling apart at the heart of things. A falling apart of the heart.

I have always been invested in beauty. It began when I was an infant, bathed in warm light and my mother's love. I was naked and she was touching me. That is my first memory, and it has served as my beacon of pleasure. I felt beautiful, whole, loved, and at peace, harmonious. I knew the unity of soul, mind, and body. I *was* that unity.

Pleasure was persuading me of its vitality and excellence.

Looking like myself is a pleasure. Looking like anyone else has never interested me. I've always known that my looks are mine alone. Familiarity with my own body, regarding, exploring, and experimenting with it every day, always keeps me aware of its particularities, such as acne and hairy legs and arms in adolescence, high cheekbones, cellulite on my thighs, broad shoulders and a small waist, a beauty spot at the top of my left rib cage.

I have never thought that thin is better than fat, blonde hair better than brunette, straight better than curls, long legs better than short, young better than old, white skin better than brown, makeup better than bareness, feminine style better than masculine, big breasts better than small—or none! I have never thought that any part of my body is better than another. Beauty hierarchies compromise pleasure. When women

and girls internalize a ranking in which the first terms in the above pairs constitute beauty, and they see that the second term describes their bodies, apologies ensue.

Hyperbeauty deprives women of peace and power. Pleasure and peace go hand in hand. Pleasure and power go hand in hand. Girls who grow up in the atmosphere of hyperbeauty may be strangers to their own pleasures.

Many authors have discussed the twenty-first century extremism of hyperbeauty, its radical damage to girls, from toddlers to teenagers, and the distress and perplexity felt by older generations, which includes mothers trying to navigate the pinkification, sexualization, and pornification of their daughters. Two especially smart, thorough, and readable books are Peggy Orenstein's *Cinderella Ate My Daughter: Dispatches from the Front Lines of the New Girlie-Girl Culture* (2012) and Susan J. Douglas's *Enlightened Sexism: The Seductive Message That Feminism's Work Is Done* (2010).[1] From the vaunted greatness of pole dancing as exercise to the assertion by young women that looking supersexy is their empowering choice to the tarted-up costumes and parading of preschool girls on the reality show *Toddlers and Tiaras* to the appraisal of unmodified midlife and old women as unfit to be seen, Douglas and Orenstein examine the brief history of hyperbeauty as they smartly critique it. Both authors review the place of performance in hyperbeauty, which entails pleasing someone else before or instead of pleasing oneself, such as the judges for the *Toddlers and Tiaras* pageants, the friends a girl has on social media, or the boy who wants a blow job without caring what the girl desires.

Often we are pleased by what satisfies the hyperbeauty market. That is untrue pleasure. In order to know what truly pleases us, one effective way is to start with suffering. Mind, body, ethics, or finances may suffer.

Impulsiveness, conformity, fear, muddle, distraction, and docility help people bypass suffering so that they don't notice it. Time for reaching

into oneself, to be conscious and quiet in order to identify suffering, will likely be painful and embarrassing. It may bring surprises, and it can heal the suffering when someone lets it be, lets it flow through her and clear itself out, leaving her able to feel the honest power of what pleases her in contrast to the fragile power of false pleasures. Feeling is healing, and true pleasure heals those sickened by hyperbeauty. Healing is a practice. Healing can be instantaneous, and it can also take a lifetime. Both can be happening at once.

Suffering may appear to be too serious a word for the seemingly inconsequential hurts that women and girls experience in the reign of hyperbeauty.

An example: I notice twenty-year-olds on the University of Arizona campus pulling down the shortest of skirts and shorts in unsuccessful attempts to cover their butt cheeks for any length of time. I have frequently used the U of A Rec Center and library, and the school is in Tucson, where it is warm to hot most of the year, so the minuscule outfits are on view pretty much all the time. Clothing that rides up is a minor annoyance, you say. Yes, and at the same time, regularly pulling at your clothing in order to be comfortable is *un*comfortable. Simple as that. I've been there (but never with clothing as teeny as those that are all over campus). You're worried about yourself, because you're constantly in danger of going too far from decorum. You've confined yourself mentally as well as physically in your hypersexy duds, and that is neither peaceful nor pleasurable.

Sometimes a pleasure can change. What once pleased us now causes suffering. I used to wear high heels for teaching, performing, dinners at fancy restaurants, and special events. Then I began to observe how my posture was being thrown out of whack in heels. I appreciated the suffering of toes pushed against the front of the shoes, and when relieved of them, the tightened soles of my feet. I began performing barefoot, and for everyday and dress-up I now search for elegantly funky shoes and especially booties,

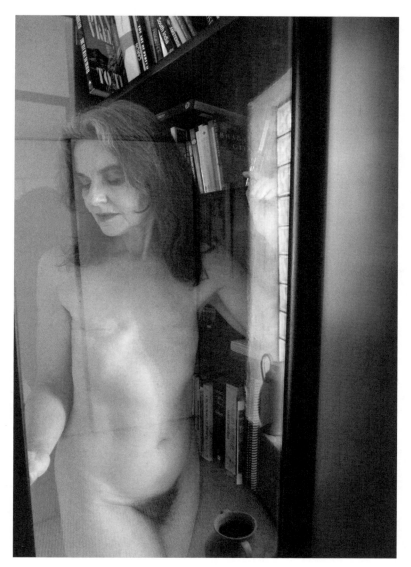

THE ELEMENT OF BOOKS, 2014

a favorite footwear type, that are flat or have very low, sturdy heels. And always wide enough to truly accommodate my feet. At the same time, I love Coco Chanel's maxim: keep your heels, head, and standards high.

SPANX BODY-SHAPING UNDERGARMENTS please the wearer because she looks slimmer than her regular self. To me, they sound intolerable. A perfect fit for making a woman suffer to comply with hyperbeauty thinness. The name Spanx stopped me when I came across it in a book written by a woman in her forties who decided to try Spanx wear under a gown for a special event. Her description of how the purchase felt on her body—punishing—sent me to the brand's Website, where the Slimming Level, as the sales copy read, intrigued me. The choices *began* with Medium—no fooling around at Spanx—and intensified to Super and Super-Duper.[2]

Medium "offers a close, yet comfortably forgiving fit." The language hedges. Come on, a medium body-shaper *compacts* your body in order to minimize it. And why does your body need to be forgiven? Super "flattens the stomach, snugly contouring to the curves." My internal organs love freedom to move where my breathing and eating, my ordinary stretches, bends, and twists, and the fluids inside my body take those organs. Super-Duper seems to require a wearer's serious adjustment of her comfort: "Powerfully transforms your physique, targeting specific problem areas with zoned compression." The language has become distinctly more strenuous for garments that attack a woman's body where it gets out of line.

Body as enemy, body as sheer matter, body as exterior only.

Spanx bears the flavor of S & M: spanking can be fun! And Spanx is a fun name, cute. A woman could think of her body as spanking new in its freshly crushed form. For most people, however, spanks hurt and spanks are actual punishment.

I've read that many celebrities wear Spanx and swear by them. I figure, in Spanx everyone is a regular person: they've all suffered.

Pleasure provides basic sanity, whereas hyperbeauty is perfectly crazy. It gives women no peace. Grounded in basic sanity, giving ourselves peace, we can enjoy creating ourselves as art, an art of unapologetic beauty. Creating herself as art will structure a person's choices in clothing, makeup, the food and beauty services she consumes, and the rituals, of exercise and skin care, for example, that she will practice in order to look the way she desires, but that the deeper choice be basically sane is the truly important one. Art exceeds mere self-expression.

"Basic sanity" is a beacon in the teachings of the Buddhist master Chögyam Trungpa, and it is each person's inherent goodness, health, and clear perception.[3] One does not strive for basic sanity or congratulate herself for it. Reaching into oneself helps to draw it out from the hiding place in which we too often keep it.

Trungpa holds that basic sanity must be the foundation of art, and any art that one creates issues from her whole life, soul-and-mind-inseparable-from-body. So she must cultivate gentleness, generosity, and genuineness, first of all, with herself, so that they infuse her life and art—her unapologetic beauty. Hyperbeauty is ungentle and stingy—aggressively inflexible, overbearing in its ubiquity and exhibitionism, tormenting girls and women with you-can-and-must-buy-me come-ons, with fakeness that purports to be real, both of which do violence to a person's self-respect.

Artists, like anyone, may express troubles akin to those that characterize hyperbeauty. They may be arrogant, exhibitionistic, aggressive, tormenting, or cruel, and Trungpa admonishes that those traits and any others of an ungentle nature must be tamed. Otherwise, they will infect one's art and sicken those who see and experience it, which for an unapologetic beauty is everyone with whom she comes into contact. An unapologetic beauty is the most public of artists.

Taming oneself is a lifelong process, in which fears arise many times. Hyperbeauty induces women and girls to fear their bodies. Observing

fear rather than reacting to it with suppression, avoidance, anger, or self-critique familiarizes one with openness, so that she can be receptive to her basic sanity.

Art is not the dumping ground for an unrequited romance with oneself, a materialization of psychic ills that sustain stagnation and cowardice, a lack of change or dread of it and of our own uniqueness.

Art is a passage, a becoming. That means we can relax, which hyperbeauty disallows. Relaxation enables basic sanity to surface. Relaxing means too that in our becoming we may explore cosmetic surgery, try too hard, or overdo a look; that young girls may join their peers in sporting vehemently sexy clothing; and that midlife women may doll up in it too. The pressures of standardizing ourselves to hyperbeauty may, for some of us, be part of the passage to creating ourselves as an art of unapologetic beauty. Arrival at the destination may be intermittent, touch and go, or a homecoming that secures us in a foundational peace. We can stabilize ourselves in any of those arrivals, sanctuaries from the destabilizing craziness of hyperbeauty, while being aware of it and compassionate about the effects of its pressures.

In our passage to creating ourselves as an art of unapologetic beauty, we can hurt ourselves and others, because the evidence of pressures to accommodate hyperbeauty may make an onlooker roll her eyes or shake her head or feel simply sad at what she may judge as ugly, stupid, crude, absurd, or deplorable. Maybe she saw a preteen in a tube top, black lace micro-skirt, and high heels; a coworker whose thin jersey, low-cut top showed off her big breasts; a shopper whose super-smooth face resembled wax; or a teenager whose scrawniness she suspected was self-inflicted. We make errors and we make fools of ourselves in the name of art. Every artist does. Yet an unapologetic beauty, taming herself into peace, into pleasure, is responsible too for taming others.

Art is of consequence and has consequences.

Trungpa proclaims the consequentiality of art with almost shocking boldness: "Art is extraordinarily powerful and important. It challenges people's lives. So there are two choices: either you create black magic to turn people's heads, or you create some kind of basic sanity. Those are the two possibilities, so you should be very, very careful."[4] He doesn't say "black magic" frivolously. He means that art can harm people. Black magic art can be enchanting, seductive, and intoxicating, like hyper-beauty, which certainly can be head-turning. And he gives no middle ground—you're creating black magic or you're helping people.

Trungpa acknowledges that following a path of gentleness, generosity, and genuineness in the making of art "may seem insignificant,"[5] and we might think the same about creating ourselves as artworks of unapolo-getic beauty, but a sentence later he gives us a profound send-off: "You could play a tremendous role in developing peace throughout the world."[6]

Hyperbeauty thrives on self-obsession and worry, which repeated commiseration among friends about their beauty failings exacerbates. Those conversations build a solidarity of women and girls at war with themselves, and that is a kind of anticommunity or uncommunity, because community needs to be for the common good. Unapologetic beauty flourishes in benevolent community, where girls and women who create themselves as art through basic sanity fortify and enrich one another's beauty. They build communities of peace. Communities of peace are communities of pleasure.

Language

WHERE LANGUAGE LEADS WE FOLLOW. It can be a guiding light. It can also be a guiding gloom. So we need to listen to what we and others say, face to face, online—anytime—when we are referring to a woman's or girl's appearance or to a female body part, then to register our thoughts and feelings, and to correct at least our own language, if not that of a blogger, friend, grandmother, or spouse.

Language is full of choices, but common words and phrases that describe or bear on women's and girls' appearance are a stock vocabulary that can be mean, deriding, sexist, and ungraciously generalized.

What we think determines what we say: the stories we tell about beauty—our own, others', and society's notions about it; the way that we apologize for our perceived beauty flaws; and our definitions of beauty itself. Generic language describing girls' and women's appearance comes out of us spontaneously and even impulsively, because we are born into language, which we customarily use without thinking about it, so that we unhesitatingly repeat what we hear and read. Like apologies, words about appearance circulate so naturally that we rarely notice exactly what we say.

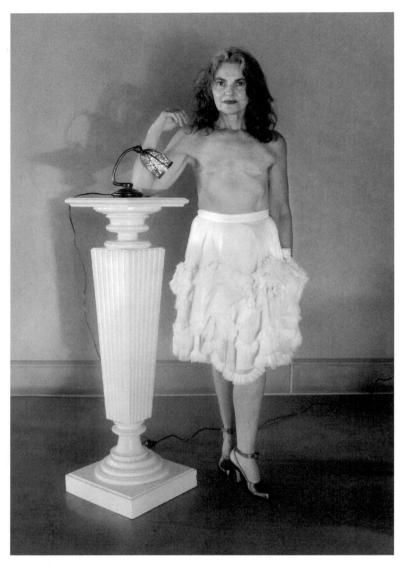

PILLARS, 2015

Wake up to discourse that annoys and angers you. Finding it is unlikely to be a chore.

BOOBS AND LITTLE OLD LADY are figures of speech, as are *eye candy, cougar, babe, old bag,* and *wench,* which means that human beings made them up; and that means we can craft a new vocabulary. It can be for private or public use.

In my own life, two examples immediately come to mind of invented language that I love. My second husband surprised me with *Silver Sex Lady,* which he said would describe me at the age of seventy. I loved the name when he originated it, in my forties and his thirties, and I love it now. *Silver* conveys maturity, experience, and radiance. *Sex* conveys vigor and desirability. *Lady* conveys refinement and sophistication. Big power.

I needed a name for the e-mail account associated with my Website, and *Aphrodite* quickly presented itself: aphrodite@joannafrueh.com. Aphrodite is the ancient Greek goddess of love, beauty, sex, laughter, bathing, smiles, and creativity. I thought, "What fun!" and I identify with her attributes.

Silver Sex Lady and Aphrodite help me to shine.

One of my favorite songs is "This Little Light of Mine." It proclaims where and how that light will shine, and the chorus inspires me to "let my little light shine." That gospel classic is divinely happy and effective, because it teaches people that they have a light and that it can shine all the time. If your discourse about girls' and women's appearance, and your own, does not help any part of you to shine, then reconsider it and invent.

Boobs is commonly used by women and girls to describe their own and others' breasts. However, it displeases some of us. (Boobcentricity, the focus of my earlier chapter "Culture's Breasts I," acknowledges that commonness and, in "Culture's Breasts II," a woman who speaks of her postmastectomy breast resizing and reshaping terms her breasts *boobs.*)

My beauty hero Kat enters our March 13, 2015, e-mail chat about *boobs*: "Always hated that word, yet it's the word even I use at times. It's a disgusting word." I respond: "The word just sounds gross, jiggly. It's exceedingly inelegant. Besides, of course, suggesting that boobs belong to boobs." Concurring through free associations, she writes, "The booby bird, the flappy, irrelevant but lusted-after appendage, and the stupidity that accompanies that lust," and ends with the blunt "inert things." Boobs have a pathetic, humorous momentum of their own—why in the world do they arouse such inane sexual desire?—while being simultaneously immobile, stuck on the body in a nonvolitional way, unlike an arm, which is relevant to many activities. Boobs can't help themselves—they attract asinine levels of sexual desire. In contrast, breasts have a job to do— feeding babies. Kat's final e-mail on the matter states, "Big clunky things on a second-rate, exploitable human body." In her e-mails, the word *things* points to the dehumanization of breasts, because they belong to an inferior class of human beings—females.

Little old lady is an overused description of old women and one of my most disliked. It layers weakness upon weakness. An old woman might indeed be short, slender, and refined, but that is not the picture painted by the phrase. Rather, she is typecast. I see a frail, wizened female in matronly clothing, bent and laughed at or avoided, talked down to, and ignored. I suppose she could be *spry,* another blanket term, applied as if it were the only available adjective to indicate an old woman who is vigorous and quick-witted. I love the word *lady,* which wafts deference, esteem, cultivation, and elegance, but not here, where it feels pinched, faceless, bodiless, and reduced, like the caricature that *little old lady* designates.

"She's too old to wear that," "Dress your age," and "That makes her look old" rose to the top of my beauty hero Ariana's problematic phrases describing women's appearance in an e-mail from 2015. These terms indicate frustration with pronouncements that excoriate women through embarrassment to conform to so-called age-appropriate dress and

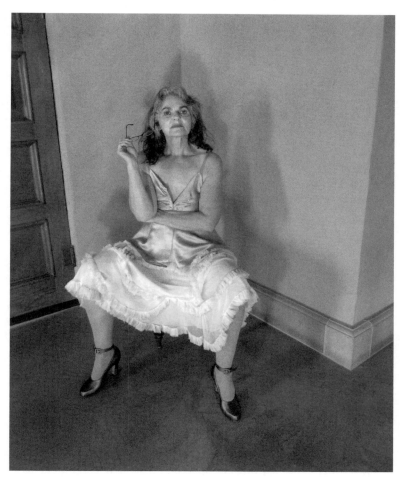

PROFESSOR FRUEH, 2015

behavior. I hope that Ariana, who was thirty-two when I wrote these paragraphs based on her e-mail, continues to dress for fun and flair in puff sleeves and vintage finds as long as she feels like it. The category of peeving expressions from which Ariana's come admonishes women to follow rules and enforce them with one another. How we look when we step out the door does require respect for others, but an etiquette of appearance does not need to inhibit anyone's individuality.

Language about women and girls is often a language of crisis. Such as the language of aging, which is really a language of negativity about growing older and being old. The language of aging throws women and girls into mental disarray, because they know that aging is a continuous doomsday beginning in one's teens. (Fatness is another prime doomsday idea that contaminates girls' minds before adolescence.)

Anti-aging is the most unappealing of the phrases used by skin care companies to strike fear in the hearts of females regarding the decline associated by the worlds of fashion, beauty, and medicine with the constant maturing that no one can avoid. We know that anti-aging products are weapons—to fight wrinkles, mottled tone, rough texture, and lack of utter tightness. Choosing my *battles* is sometimes difficult; I know that I don't want cosmetic surgery or fillers, but the enmeshed societal filters of fashion, beauty, and medicine offer plenty of other options—lasers, peels, this potion and that. I pick what I hope are not poisons. Battle does not excite me.

I want to live filled with pleasure about myself. A language of pleasure, in contrast to a language of crisis, is one way to go. Language and action are pals, in continual play with one another. Language not only influences a person's behavior; language activates behavior. Words of celebration work: I am Silver Sex Lady, Goddess of Roses, Aphrodite. Who are you?

THE FOUR Cs OF *Creating Beauty*

REPLACE THE THREE Cs OF COMPLAINT—criticism, competition, and commiseration—with the Four Cs of creativity. They do more than empower you. Practice them and you will become powerful—full of power.

1. *Claim* your beauty heroes.

This will ground you in reality and your own life. You'll be training yourself to perceive beauty anew. When you notice that beautiful girls and women surround you, the impaired vision that sees hyperbeauty as ideal will disappear along with starstruck blindness.

2. *Compose* yourself with contentment over consumerism.

Every day we compose a picture that is our appearance. Consumerism drives discontent about it, with beauty products and services that congest our minds and bedevil our genuine pleasure. Contentment is an energizing and activist practice.

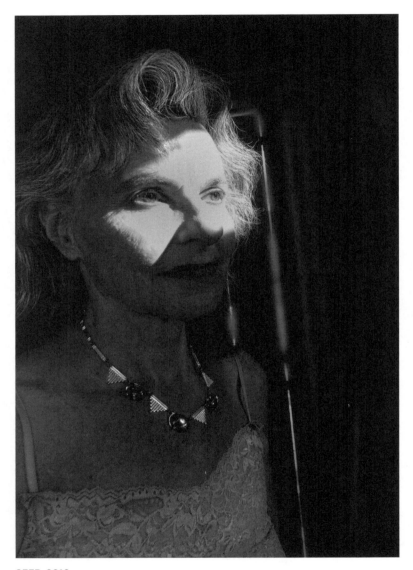

SEER, 2016

3. *Compliment* girls and women in your everyday life.

Helping women and girls experience their beauty benefits society because it builds their confidence and happiness. Your compliments must be sincere. As complimenting becomes part of your daily life, you may become aware of all the times that people compliment *you*. And you will likely find your compliments rejected through some form of self-criticism that I discuss in "Apology." Sometimes the person you compliment will not respond at all. You may find that you are no exception to those behaviors. No matter. Continue the praise. The practice of complimenting asks that we learn both giving and receiving.

4. *Craft* your own language of beauty.

Start inventing new linguistic pictures. Catch yourself when you use the default idiom that I examined in "Language." Doing this with others is fun, as together you gain awareness of the impoverishment of beauty language and originate new ways to speak about beauty and to see it.

Glossary

beauty: (1) the pleasure of pleasing *ourselves*; (2) infinite radiance; (3) an affect or feeling rather than a material object; (4) an impact generated by the creative imagination; (5) not a commodity; (6) a soul-and-mind-inseparable-from-body value.

unapologetic: (1) courageous; (2) unashamed; (3) mentally spacious; (4) self-knowing; (5) luxuriously at ease; (6) lovingly self-accepting.

unapologetic beauty: (1) the ever-changing and imperfect condition of pleasure in oneself that is not bound by age, economic or educational status, clothing size, racial characteristics, sexual orientations, bodily

proportions, or societal enforcements of a two-gender system; (2) liberation from the perversity of stubborn beauty standards; (3) an art of self-creation that occurs over a lifetime; (4) dynamic integration of a real and imagined self: what someone is born with and what she organically and artistically makes of it; (5) unquantifiable originality; (6) the projection of character; (7) the sovereign choice of each girl and woman; (8) global appreciation for female variety galore.

ACKNOWLEDGMENTS

Joanna

My gratitude to the following people is boundless: Kathleen Williamson, Renee Wood, Elizabeth Hykes, Suzanne Dahlin, Leslie Klein, Deborah Rubin, and Jill O'Bryan. They were with me from high times to rocky slogs and still are. Whether their help was intellectual, practical, emotional, or spiritual, its love and wisdom inhabit *Unapologetic Beauty.*

The interviewees were stunningly generous with their honesty and give the second essay in the book its crucial realness.

Frances

Lisa Jo Roden's enduring friendship, fine eye, and superior Photoshop skills have made editing the photographs for this book fun and easy.

Together

Friends and associates and some mystery folk gave beneficently to our Kickstarter campaign for *Unapologetic Beauty,* and Jovan Erfan was the videographer for our Kickstarter video. Her deep aesthetic and intellectual intelligence were cornerstones of the joy of our creative triad.

We thank all the good people at the University of Minnesota Press who made this entire editorial process a pleasure, including Danielle Kasprzak, Anne Carter, Laura Westlund, Anne Wrenn, Louisa Castner, Rachel Moeller, Maggie Sattler, Lisa Farnam, and Frances Baca.

NOTES

..................................

Research material includes but is not limited to scholarly and popular books, interviews with doctors and with scholars and artists, personal conversations, and an array of online sources.

An Art of Friendship

1. See Frueh, "Erotic Voices: A New Language," *Tucson Weekly,* March 9–15, 1988, 6, 16; "Elegant Edge," in *Psychologue: Frances Murray* (Tucson, Ariz.: Etherton Gallery, 2007), 4–6; and "Elemental Wonder," in *Constellations* (Tucson, Ariz.: self-published, 2014).

2. Frueh, *The Glamour of Being Real* (Tucson, Ariz.: ErneRené Press, 2011); and Frueh, *A Short Story about a Big Healing* (Tucson, Ariz.: ErneRené Press, 2013).

3. Marsha Meskimmon, "Art Matters: Feminist Corporeal-Materialist Aesthetics," unpublished manuscript, 2015.

4. Ibid.

5. David Jay, *The SCAR Project, Vol. 1, Breast Cancer Is Not a Pink Ribbon* (New York: The SCAR Project, 2011).

6. Meskimmon, "Art Matters," quoted in Joanna Frueh, *Monster/Beauty Building the Body of Love* (Berkeley: University of California Press, 2001), 101.

Culture's Breasts I

1. Octavus Roy Cohen, *Don't Ever Leave Me* (New York: Macmillan, 1946).

2. See the breast surgery section in the Smart Beauty Guide, from the American Society for Aesthetic Plastic Surgery, http://www.smartbeautyguide.com. Although no numbers appear, reckoning them is easy. Click on *Procedures,* then click on *Breast.*

3. See "Possible problems with breast reconstruction," http://www.cancerresearchuk.org/about-cancer/breast-cancer/treatment/surgery/breast-reconstruction/possible-problems; and https://www.breastcancer.org/treatment/surgery/reconstruction/types/implants/risks.

4. The woman is Sheyla Hershey, whose Website no longer existed when I tried to access it in June 2015. Neither news articles nor a Wikipedia bio about her seemed entirely reliable or satisfactorily up to date. Nonetheless, two stories in the relatively dependable *Huffington Post* and one in the tabloid the *Daily Mail* provide basic information about her story. See "World's Biggest Breasts: Sheyla Hershey Sets Record with 38KKK Bust," https://www.huffingtonpost.com/2010/09/10/sheyla-hershey-worlds-biggest-breasts-removed_n_711785.html; and Deborah Arthurs, "I Feel Whole Again: Woman Obsessed with Having World's Largest Breast Implants Tells of Her Joy at Being 'Reinflated' after Death Scare," http://www.dailymail.co.uk/femail/article-2065621/Sheyla-Hersheys-joy-having-worlds-largest-breast-implants-reinflated-death-scare.html.

Culture's Breasts II

1. Sally Koslow, "Holy Cow. Look at Me Now," *AARP* magazine (August/September 2014), 44.

2. Sally Koslow's Website states nothing about her age, but in a blog interview, which appears to be from 2015, she states that she is in her sixties. See "The Balance Project No. 168: Sally Koslow, Novelist," accessed February 23, 2018, https://susieschnall.com/balance-project -no-168-sally-koslow-novelist/.

3. Koslow, "Holy Cow," 44.

4. Lewis Mumford, *The Myth of the Machine: The Pentagon of Power* (New York: Harcourt Brace Jovanovich, 1974), 18–19, graphic section II, uses the term *technological exhibitionism*.

5. Leona reports regarding the United States that "statistics on this are all over the place," from as few as 5 percent of women [diagnosed with cancer in one breast] to as many as 30 percent. "In my experience the number is closer to 30 percent." She gives the standard reasons for contralateral mastectomy—younger age, positive family history, greater level of anxiety about recurrence, having had multiple biopsies in the diagnostic process (even if benign biopsy in contralateral breast)—and adds: "Not mentioned in the studies, but in my experience, other important factors in this choice include desire for symmetry in reconstruction; and women who are very large-breasted often choose contralateral mastectomy given the challenges for symmetry as well as comfort/discomfort if one large breast is left in place."

6. Fort responded to a questionnaire devised by Frances and me, in February 2015.

7. Zarling's remarks are from an April 2015 e-mail in which she responds to our questionnaire.

8. All of her comments are in response to a questionnaire for artists that Frances and I created in 2014.

9. Sprinkle's statements come from her e-mailed responses, in February 2015, to Frances's and my artists questionnaire.

10. See http://anniesprinkle.org/projects/archived-projects/annie-sprinkles-bosom -ballet/, for photos of the *Bosom Ballet.*

11. See "Explore Purple Hearts, Contemporary Paintings, and More!", https://www.pinterest .com/pin/751186412816970012.

12. "Beth Stephens, Annie Sprinkle, and the Love Art Lab, Interviewed by Lindsay Kelley," January 7, 2011, San Francisco, http://totalartjournal.com/archives/773/interview-with -beth-stephens-and-annie-sprinkle-of-the-love-art-lab-2/.

13. Ibid.

14. Alshaibi answered our artists' questionnaire in March 2015.

15. See the following sources for information about breast cancer in the Middle East. "Breast Cancer Arabia," http://breastcancerarabia.com/things-to-know; Aya Nader, "Egypt Hosts Middle East's First Breast Cancer Hospital," May 18, 2015, https://www.dailynewsegypt .com/2015/05/18/egypt-hosts-middle-easts-first-breast-cancer-hospital/; Jessica Sarhan, "Women Urged to Fight Breast Cancer Stigma," September 5, 2014, https://www .aljazeera.com/news/middleeast/2014/07/lebanon-women-breast-cancer-stigma -2014718134537878942.html.

My Breasts

1. My lover mentioned in this chapter, Kathleen Williamson, and I have since gotten married.

2. *Prosthetic aesthetic* popped into the head of Kathleen when we were having a conversation about the breast chapters of this book. Neither of us had heard it before. Curious about the phrase, I found later that day that a book titled *The Prosthetic Aesthetic* was published in 2002, edited by Scott McCracken, Joanne Morra, and Marquard Smith (London: Lawrence & Wishart, 2002).

3. As Dr. Leona Downey wrote in a 2015 e-mail, "Women who are slim, who are very athletic, or who were relatively small-breasted originally may have a slightly lower likelihood of choosing reconstruction."

Apology

1. In Bianna Golodryga and Don Ennis, "Botox: New Trend for Teenagers," August 13, 2010, https://abcnews.go.com/GMA/BeautySecrets/botox-trend-teen-girls/story?id=11393081, an eighteen-year-old girl talks about her Botox treatment to prevent wrinkles.

2. Dangin is quoted in Lauren Collins, "Pixel Perfect: Pascal Dangin's Virtual Reality," *New Yorker,* May 12, 2008. https://www.newyorker.com/magazine/2008/05/12/pixel-perfect.

3. Donnalou Stevens, "Older Ladies," https://www.youtube.com/watch?v=O4QzHeUE-CM.

4. See https://www.dermanetwork.org/articles/anti-aging-treatments/.

5. I use quotation marks here because of my disgruntlement with the term *anti-aging,* which is in common usage in the beauty industry. See my comments on names associated with age in the chapter titled "Language."

Hyperbeauty

1. Simon Romero, "Argentine City Takes Beauty Off Its Pedestal," *New York Times,* December 22, 2014, https://www.nytimes.com/2014/12/23/world/argentine-city-takes-beauty -off-its-pedestal.html.

2. Julie Turkewitz, "After a Spa Day, Looking Years Younger (O.K., They're Only 7)," *New York Times,* January 2, 2015, https://www.nytimes.com/2015/01/03/us/after-a-spa-day -looking-years-younger-ok-theyre-only-7.html.

3. See https://www.huffingtonpost.com/2014/03/30/jennifer-lawrence-plastic_n_ 5059641.html.

4. Ibid.

5. Sarah Wu, "10 Boy Beauty Products That Are Even Better Than Our Own (Steal Them ASAP!)," *Teen Vogue,* https://www.teenvogue.com/gallery/beauty-products-for-boys -worth-stealing.

6. Alexandra Stevenson, "Plastic Surgery Tourism Brings Chinese to South Korea," *New York Times,* December 23, 2014, https://www.nytimes.com/2014/12/24/business/international/ plastic-surgery-tourism-brings-chinese-to-south-korea.html.

7. Sharon Holbrook, "Beauty Tips for Girls, from Lego," *New York Times,* March 16, 2015, https://parenting.blogs.nytimes.com/2015/03/16/beauty-tips-for-girls-from-lego/.

8. Stacy L. Smith, Marc Choueiti, Katherine Pieper, et al., "Gender Bias without Borders: An Investigation of Female Characters in Popular Films across 11 Countries," Geena Davis Institute on Gender in Media, Rockefeller Foundation, USC, and UN Women, https://seejane.org/wp-content/uploads/gender-bias-without-borders-full-report.pdf.

9. See https://www.dudeproducts.com.

10. Price was found on a labiaplasty guide Website, http://www.labiaplastyguide.com, accessed February 2015; the site is no longer available. The cost varies depending on the surgeon's experience—the best ask for more; geography—cosmetic surgeries in big cities are likely to be pricier than in rural and suburban areas; anesthesia and facility costs; techniques—the latest ones may be more expensive; consultation—some surgeons charge for it; and incidentals that you need to pay for—medications, medical supplies, blood work, and other tests. The ASPSA (American Society of Plastic Surgery Associates) gives $2,286 as an average for only surgical fees for vaginal rejuvenation, which generally includes vaginoplasty (vaginal tightening), and/or vulvaplasty or labiaplasty. See http://www.smartbeautyguide.com.

11. An advertisement for shopbazaar.com, *Harper's Bazaar* (May 2014): 283.

12. See http://www.africanamericanrhinoplasty.com. The surgeon is Oleh Slupchynskyj.

13. Love Your Lines had 100,000 followers when I accessed it February 2015.

14. Eff Your Beauty Standards, an Instagram account, had 92,300 followers when I accessed it in February 2015, and 370,000 in March 2018.

15. I accessed her website in March 2018, and it had changed.

16. Esther Honig, "Before & After," http://www.estherhonig.com; this Website is no longer available.

17. "Stars without Makeup," http://www.usmagazine.com/celebrity-beauty/.

18. "How much of the human body is made up of stardust?" Physics Central, http://www.physicscentral.com/explore/poster-stardust.cfm, asks and answers: "[The] amount of stardust atoms in our body is 40 percent."

Beauty Redefined

1. The measurements are from Monroe's dressmaker; I found them in Sadie Stein, "For the Last Time: What Size Was Marilyn Monroe?" June 22, 2009, http://jezebel.com/5299793.

2. Crispin Sartwell, *Six Names of Beauty* (New York and London: Routledge, 2004), xii.

3. Both definitions are from ibid., xii.

4. A beautifully wabi-sabi book about the subject is Leonard Koren's *Wabi-Sabi for Artists, Designers, Poets & Philosophers* (Point Reyes, Calif.: Imperfect Publishing, 2008 [1994]).

5. I thank Maggie Hill-Kipling for bringing the art of kintsugi to my attention.

6. I have quoted part of Sappho's fragment 16, found at the Website of the Stanford Encyclopedia of Philosophy, in "Love and Longing," section 2.3 in "Beauty," http://plato.stanford.edu/entries/beauty.

7. Issai Chozanshi, *The Demon's Sermon on the Martial Arts*, trans. William Scott Wilson (Tokyo: Kodansha International, 2006), 102. All further page references will be noted parenthetically in the text.

The Pleasure of Pleasing Ourselves

1. Peggy Orenstein, *Cinderella Ate My Daughter: Dispatches from the Front Lines of the New Girlie-Girl Culture* (New York: Harper, 2012); Susan J. Douglas, *The Rise of Enlightened Sexism: How Pop Culture Took Us from Girl Power to Girls Gone Wild* (New York: St. Martin's Griffin, 2010).

2. That first look at the Spanx site happened several years ago. I didn't record the page on which this sizing appeared, and that page no longer exists. Nonetheless, the points that I make about the sizing language are no less valid now than they were on my first seeing it.

3. I am grateful for Chögyam Trungpa's *True Perception: The Path of Dharma Art* (Boston: Shambhala, 2008), because his thinking about the creation of art is the most affecting and effective that I have read on the subject.

4. Ibid., 24.

5. Ibid., 183.

6. Ibid.

JOANNA FRUEH is emerita professor of art history at the University of Nevada, Reno. She is author of *BRUMAS: A Rock Star's Passage to a Life Re-Vamped; Hannah Wilke: A Retrospective; Erotic Faculties; Monster/Beauty: Building the Body of Love; Swooning Beauty: A Memoir of Pleasure; Clairvoyance (For Those in the Desert): Performance Pieces, 1979–2004; The Glamour of Being Real;* and *A Short Story about a Big Healing.* She is coeditor of *Feminist Art Criticism: An Anthology, New Feminist Criticism: Art, Identity, Action,* and *Picturing the Modern Amazon.* The Joanna Frueh Archive is at Stanford Libraries.

FRANCES MURRAY is an award-winning fine arts photographer. Her photographs are in museum collections nationwide. The University of Arizona's Center for Creative Photography houses the Frances Murray Archive.